WARNING!

BOULDERING IS CLIMBING WITHOUT A ROPE, AND BUILDERING IS CLIMBING ON BUILDINGS, GENERALLY WITHOUT A ROPE AND OFTEN WITHOUT PERMISSION. THIS SOUNDS DANGEROUS AND ILLEGAL, AND IT IS. DO NOT DO IT.

THE INCLUSION OF ANY BUILDING, OR ANY ROUTE INFORMATION DOES NOT MEAN THAT A MEMBER OF THE PUBLIC HAS ANY RIGHT OF ACCESS, OR THE RIGHT TO PHYSICALLY INTERACT WITH IT IN ANY WAY. INFORMATION ON ALL BUILDERING IS MADE AVAILABLE REGARDLESS OF THE ACCESS POSITION, FOR: HISTORICAL PURPOSES; FOR THE SAKE OF COMPLETENESS; AND IN CASE ACCESS IS PERMITTED IN THE FUTURE.

THERE ARE NO WARRANTIES, WHETHER EXPRESSED OR IMPLIED, THAT THIS BOOK IS ACCURATE OR THAT THE INFORMATION CONTAINED IN IT IS RELIABLE AND NOT FICTITIOUS. THERE ARE NO WARRANTIES OF FITNESS FOR A PARTICULAR PURPOSE. YOUR USE OF THIS BOOK INDICATES YOUR ASSUMPTION OF THE RISK THAT IT DOES CONTAIN ERRORS.

THIS BOOK IS A WORK OF FICTION AND SHOULD BE TREATED AS SUCH.

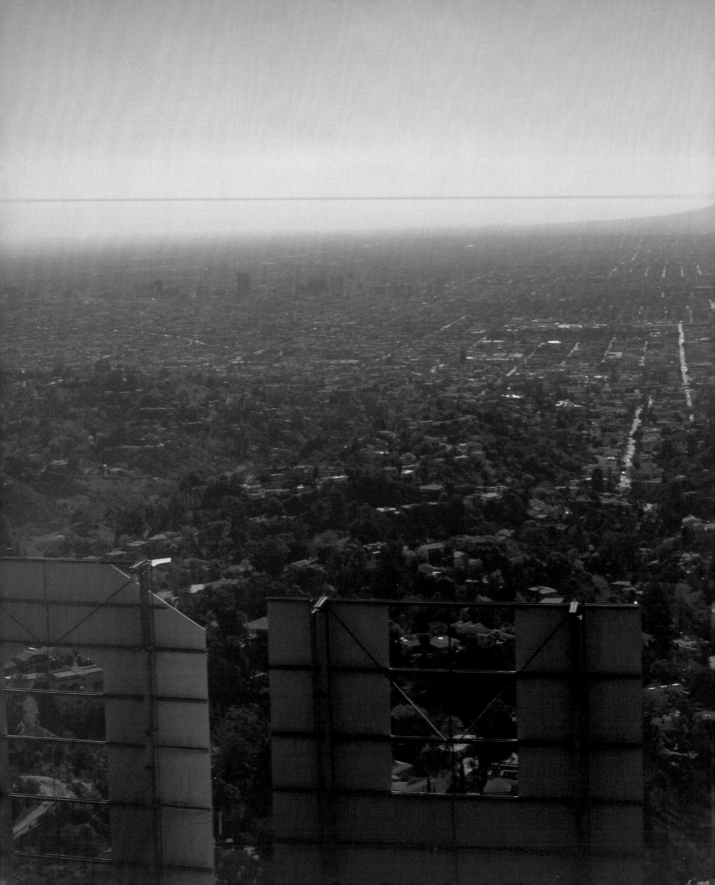

For Tania and Frank, and our Californian adventure.

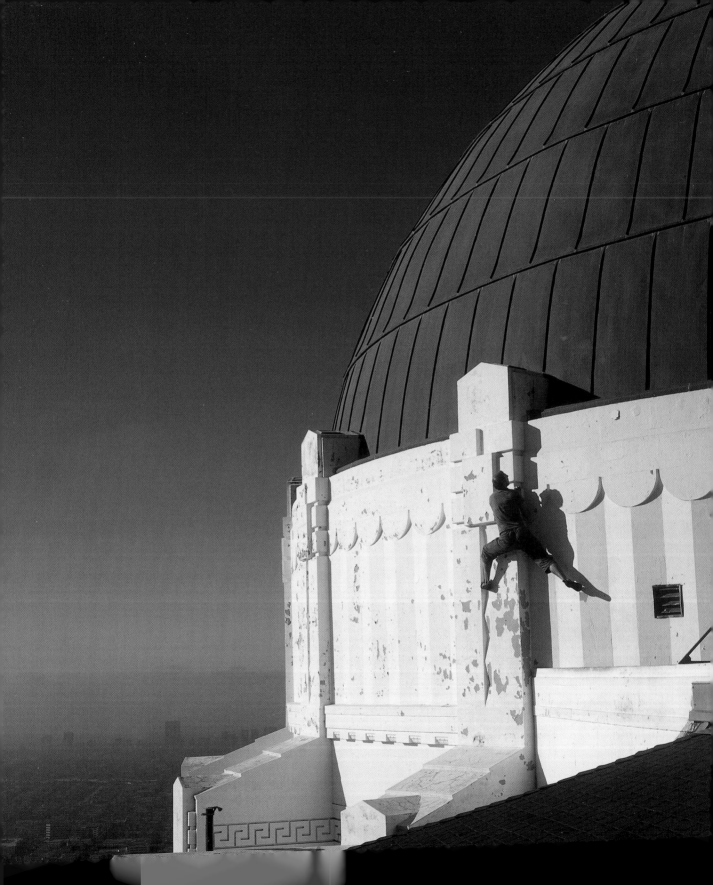

LA Climbs

Alternative Uses For Architecture

Black Dog Publishing Limited
London and New York

Some Buildering History

In 1899, Geoffrey Winthrop Young anonymously published *The Roof Climbers Guide to Trinity*. This, the first official buildering guide, contained a practical description of all routes. He contended that "it is of enormous antiquity, possessing extensive history and a literature which includes the greatest prose and verse writers of all ages". There was also some activity at Oxford, "the other place", during this time. From these early beginnings flowered the golden age of buildering in the 1920s and 30s. A subsequent lull ensued, until a reawakening of interest in the 1960s. It has barely looked down since.

In the USA as with all things, a more flamboyant approach was taken. The showman Harry F Young left the horizontal safety of the Broadway sidewalk for the vertical façade of the Martinique Hotel on 5 March 1923. His parting words to a hotel detective were "If I do it have the bath ready, if not get a shovel." Sadly, for Young and his new bride, it was the latter they required.

Young's attempted assent had been a $100 contract, and the consequence was that five weeks later an ordinance was passed outlawing urban assent, making it, for the first time, criminal trespass. The fine was ten dollars, ten days or both. (It still remains largely un-criminalised in most of Europe, with recourse only to civil action.)

Johnny Meyer ("The Human Fly of America") climbed both the Woolworth Building and the Chicago Tribune Building before setting off for Europe with the sole purpose of gathering fame and fortune "Everywhere I go people will point me out, and I can sell my nerve tonic and my picture."(!)

Following these pioneers were "The Human Spider", Bill Strothers' assent of the Brockway Building in Los Angeles, 1919; Harry Gardiner raising money for war bonds on the Brooklyn Eagle Building, 1918; and Steve Peterson, who, in 1928, fell three stories because he was past his prime – "It was a bum break."

These show-climbs petered out in the early 1930s only to reappear again with George Willig's 1977 success on Manhattan's World Trade Center. Nowadays you can't open your morning paper without seeing the irrepressible, sartorially challenged Alain Robert complete with bad hair, being escorted away by Police after (normally) conquering some major city edifice.

Parallel to these developments, buildering's ability to attract attention and to effortlessly communicate a sense of freedom to a global audience has resulted in various forms of urban ascent and the politicisation of our once secret pastime. Prison rooftop protest has been a regular feature on TV since the 70s and Greenpeace's use of builderers to unfurl banners from anything tall and unlikely has attracted the full glare of the media spotlight.

Hollywood was never happy to portray the builderer as a normal part of society, but has been unable to resist the draw of such a massive audience. As early as 1923, Harold Lloyd overcame all obstacles (the clock included) to top out and get the girl on his 5.10b redpoint project in *Safety Last*. Spiderman suffers the loneliness and isolation of his vertical activities,

and the oedipal Cagney pays the ultimate price (the big rather than little death), whilst scaling the gasholders in *White Heat*.

Los Angeles has lagged behind other major cities as a builderers' Mecca. Possibly this can be explained through the worldwide renown it has gained as the epicentre of its more famous alternative use for architecture. Skateboarders have since the 1970s looked at the built environment as pure surface and texture. Initially seeking out smooth parking lots with banked areas to reduce surfing downtime, and progressing to emptying the swimming pools of vacationing Santa Monica residents. Skaters are entirely indifferent to the function or ideological content of the fabric over which they move. Like builderers they divide buildings into sets of floating, detached, physical elements isolated from each other. Skateboarding re-edits and reproduces architecture in its own measure.

Nowadays, increasing architectural ingenuity is invested in detailing any public scheme in order to discourage both the homeless from 'loitering' and skaters from deriving unplanned and unregulated pleasure. Sloping bus benches, window ledge spikes and doorway sprinkler systems move the homeless on. Spiked handrails, banks blocked with concrete, chained stairs and the newly developed unridable surfaces attempt to similarly discourage skateboarders.

Les Tranceurs, David Belle and Seb Foucan invented 'le parkour' or free-run in the Paris suburb of Lisses in the 1980s. By drawing a straight line on a map of their home town, (like Burt Lancaster's Merrill in *The Swimmer*), they started from point A and went direct to point B. They moved gracefully and aesthetically through the urban environment, considering the elements that appeared in their way as neither barriers nor obstacles. Scaling walls, roof-running and leaping from building to building. This is parkour.

Urban planners can do little to deter the parkouristes as every obstacle appears as but a new challenge over which they must freely move.

Builderers are also seeking these new urban challenges. The days are gone when buildering was either a substitute activity born of frustration after the crags could not be accessed for yet another weekend, or the sponsored media endorsed, publicity seeking activity of the show climb. Buildering, now pursues the purity of movement, surface, texture and line in the context of the built environment. It now focuses purely on the phenomenal characteristics of the architecture, on its compositions of planes, surfaces, textures and their relationship and accessibility to the physical form of the urban climber. It offers up a new interpretation of a fractured, constructed arena through this interaction. The revolution has long since started. Stegophilists unite!

COMPARATIVE RATINGS CHART LOW TO HIGH

USA	FRENCH	UK	AUSTRALIAN
5.7	5a	4b	15
5.8	5b	4c	16
5.9	5c	5a	17
5.10a	6a	5b	18
5.10b	6a	5c	19
5.10c	6b	5c	20
5.10d	6b	5c	21
5.11a	6c	5c	22
5.11b	6c	6a	23
5.11c	7a	6b	24
5.11d	7a	6b	25
5.12a	7b	6b	26
5.12b	7b	6b	27
5.12c	7b+	6b	27
5.12d	7c-	6c	28
5.13a	7c+	6c	29
5.13b	8a	7a	30
5.13c	8a+	7a	30
5.13d	8b	7a	31
5.14a	8b+	7a	32
5.14b	8c	7b	33
5.14c	8c+	7b	33

USA	FRENCH	UK
V0	6a	5a
V1	6b	5b
V2	6b+	5c
V3	6c	6a
V4	6c+	6a
V5	7a	6b
V6	7a+	6b
V7	7b	6c
V8	7b+	6c
V9	7c	7a
V10	7c+	7a
V11	8a	7a
V12	8a+	7b
V13	8b	7b
V14	8b+	7b

LA CLIMBS

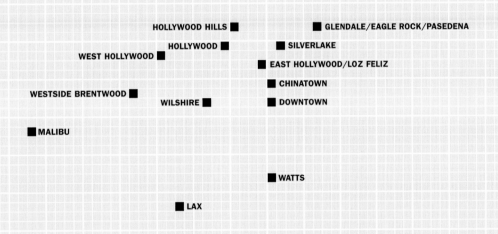

PALM SPRINGS

HOLLYWOOD HILLS ■ ■ GLENDALE/EAGLE ROCK/PASEDENA

HOLLYWOOD ■ ■ SILVERLAKE

WEST HOLLYWOOD ■

■ EAST HOLLYWOOD/LOZ FELIZ

■ CHINATOWN

WESTSIDE BRENTWOOD ■

WILSHIRE ■ ■ DOWNTOWN

■ MALIBU

■ WATTS

■ LAX

10km

5ml

"If you would see how interwoven it is in the warp and woof of civilization... go at night-fall to the top of one of the down-town steel giants and you may see how in the image of material man, at once his glory and his menace, is this thing we call a city. There beneath you is the monster, stretching acre upon acre into the far distance. High overhead hangs the stagnant pall of its fetid breath, reddened with light from myriad eyes endlessly, everywhere blinking. Thousands of acres of cellular tissue, the city's flesh outspreads layer upon layer, enmeshed by an intricate network of veins and arteries radiating into the gloom, and in them, with muffled, persistent roar, circulating as the blood circulates in your veins, is the almost ceaseless beat of the activity to whose necessities it all conforms. The poisonous waste is drawn from the system of this gigantic creature by infinitely ramifying, thread-like ducts, gathering at their sensitive terminals matter destructive of its life, hurrying it to millions of small intestines to be collected in turn by larger, flowing to the great sewers, on to the drainage canal, and finally to the ocean."
Frank Lloyd Wright

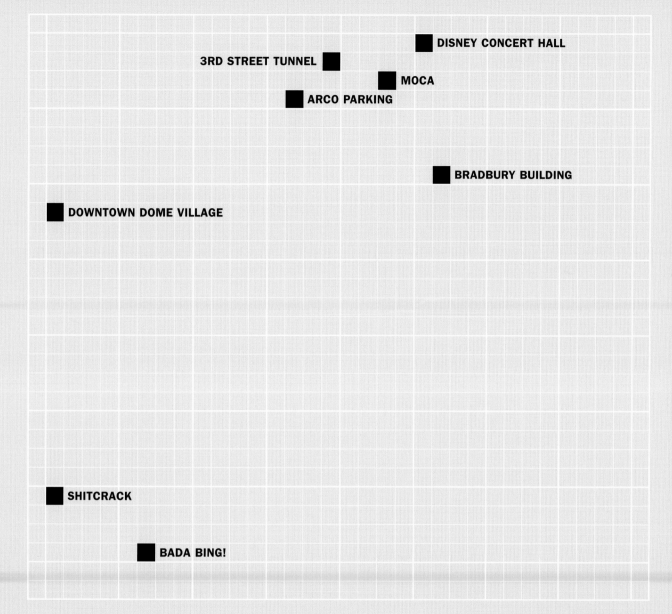

DISNEY CONCERT HALL

3RD STREET TUNNEL

MOCA

ARCO PARKING

BRADBURY BUILDING

DOWNTOWN DOME VILLAGE

SHITCRACK

BADA BING!

200m

1000ft

DISNEY CONCERT CONCERT HALL

It took 17 years for Walt's wife's $50 mill to become the majestic stainless steel sailing ship rising so proudly from the surrounding parking lots. It now looks like it might have been worth the wait.

If every world city really can't do without its very own superstar-designed/shiny/deconstructed/pop-mod tourist-magnet, then they could do (and have done) a lot worse than this.

Security during construction was fantastically lax with a lone guard, making hourly rounds. Grades and climbs changed daily during construction as the cladding was added. Now it looks that on completion the top out will go.

All walk-offs via the south roof and external stair.

Climb early, or hang out for cloud as the steel gets hot.

APPROACH

On the southwest corner of Grand Ave and 1st St.

Loads of parking, although at absurd prices.

1 HIGH ANXIETY 5.13a 245ft ★

Enter the site at the southern end of Grand, climb through the overhang of the last metal section. Hand traverse to the base of the steep left facing arete. Some of the panels are loosely fitted here and provide some extra purchase.

2 VERTICAL LIMITATIONS 5.10c 245ft ★★

Climb the horizontal glazing bars at the south end of the site. Move left under the overhang and up the first arete to the large ledge above. Walk to the folded dihedral and bridge/chimney up to the roof.

3 INDECENT EXPOSURE 5.11c 256ft ★★

Start as for Limitations, walk right along the ledge and move in behind the enclosed stairwell to the most prominent jutting sail edge. There are a few crucial rivets for holds as the climb becomes unfeasibly overhanging and shiny.

4 WHITE HEAT 5.10a 425ft ★★★

(before construction)
Start about half way along the Grand Ave façade, 20ft to the right of the lowest point of the first folding stainless steel 'leaf'. Move up 14ft of glazing to the overhang. Traverse left under the overhang. From here repeated layback moves to the crest. Move right across this increasingly exposed and airy face. Pass the corner leading to the high point and continue right to the arete. Mix bridging and desperate jamming to reach the uppermost ledge. Hand traverse to the top.

5 HOT TIN ROOF 5.9c 196ft ★

The obvious direct line through the main entrance using the horizontal glazing dividers to gain the first level. Continue straight up the windows between the stainless sails.

6 CLIFFHUGGER 5.12a 215ft ★★

Climb the overhang to the right of the main entrance. Move out onto the steel face and layback the vertical to the first level. Walk back to the right and take the line to the left of White Heat. 90ft of exposed moves on the parabolic shiny face

7 MISSION IMPLAUSIBLE 5.11c 125ft ★

From the higher level behind and left of the amphitheatre, climb the direct line to the roof.

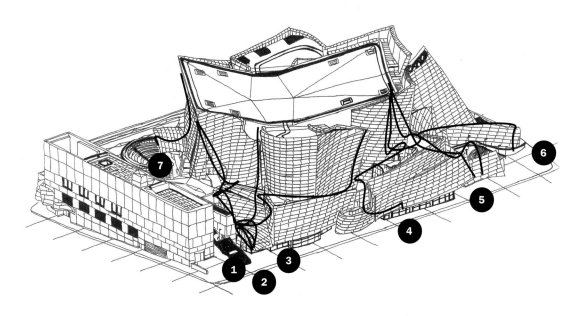

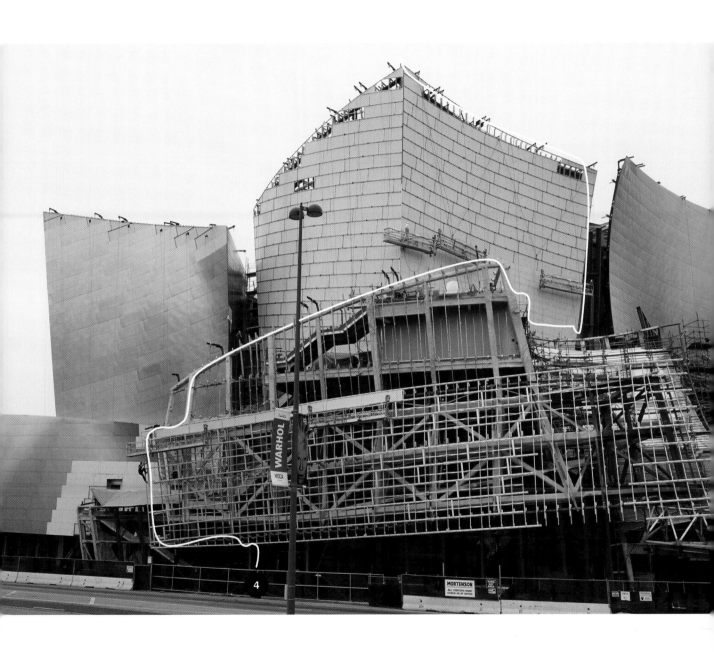

Disney concert Hall Frank Gehry 1988-2003

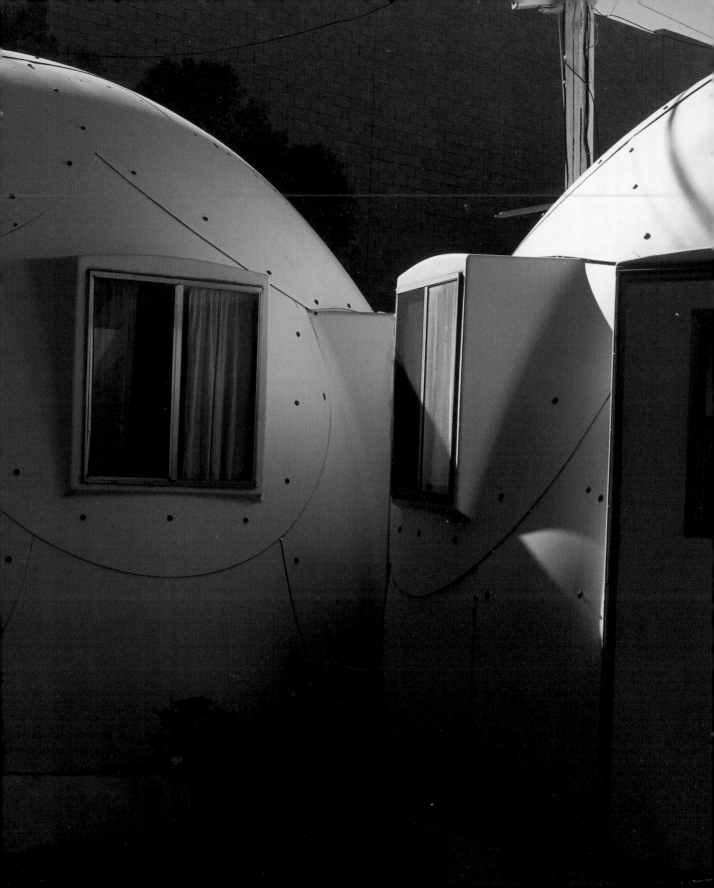

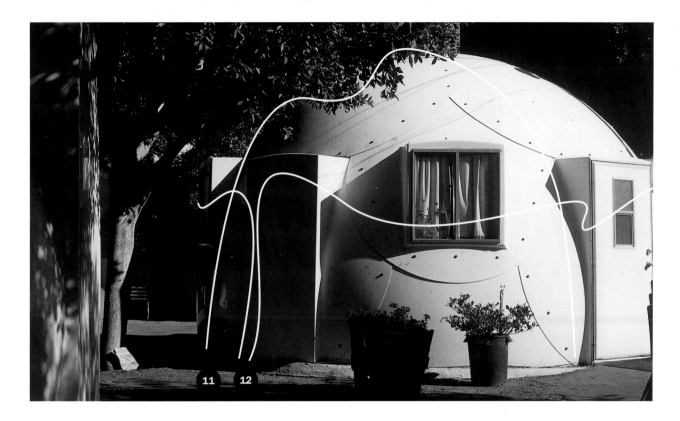

DOWNTOWN DOME VILLAGE

Justiceville founded the Dome Village in 1993 after its enforced clearance from a previous site. 20 of Bucky Fuller's Omni Domes make up this transitional housing scheme for the homeless. They sit glimpsed from the freeway, like mushrooms in the undergrowth beneath towering downtown. The domes serve as a strong reminder to the city that solutions could be sought to its massive homeless problem. They look cool too....

APPROACH

West of the 110 on Golden Ave. Park on 8th Place.

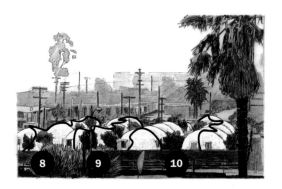

8 PAMELA V3 75ft SD

Climb dome to dome across the eastern most line. Plastic only.

9 DOUBLE D V2 105ft SD

Again as for Pamela, dome to dome, but on the second, longer row. Slightly easier as domes are closer.

10 LACTATOR V5 9ft SD *

Using any dome, but no architectural features, crimp the tiny underclings of the circular construction elements to leave the ground from seated to gain the roof. Downclimb back to seated.

11 TWO SCOOPS V1 35ft *

Approach the admin dome through the main gate. Work your way up between the door and window to gain the top. Descend and bridge to the dome immediately behind (east). Climb the blank surface to the top and descend the back side.

12 UTOPIA V4 32ft

Circumnavigate any dome without going above the window/door line. Add a grade for a sit start. Can also be climbed as a pursuit race where climbers start at opposite sides and chase each other until one is caught or someone falls.

13 EGGHEAD V5 150ft **

Primarily a route finding problem – move from dome to dome without backtracking taking in all 20 domes.

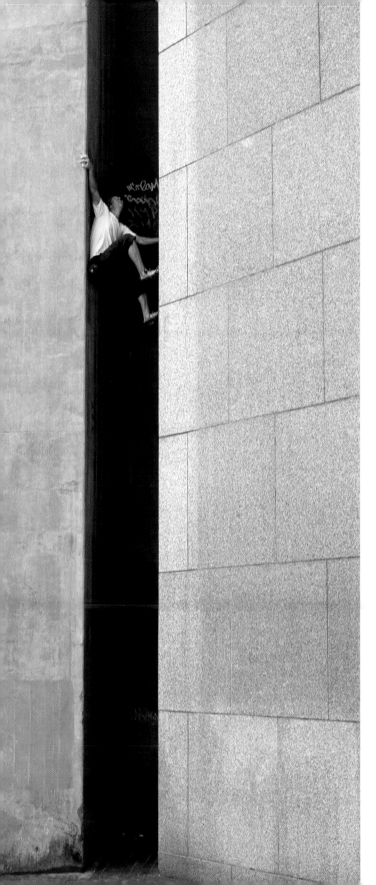

3RD ST TUNNEL

Nicely concealed at the western end of this one way underpass. The climb is kind of sexy in a dirty sort of way. The phallic vertical abuts a horizontal love tunnel....

A single route only, with a pissy-crappy-stinky bum-hole start that leads to 70ft of hamstring chimney agony. Wear an old shirt, as it'll never be clean again.

APPROACH

Under Bunker Hill, Flower St end of tunnel.

14 SLOT 5.9c 70ft **★★**

Not many options here, just straight up. There is some friction provided by the left-hand wall, but the right hand face is very slick. No chance for protection, so haste is essential to avoid tiring at the top. Tricky crux exit move – just when you don't need it.

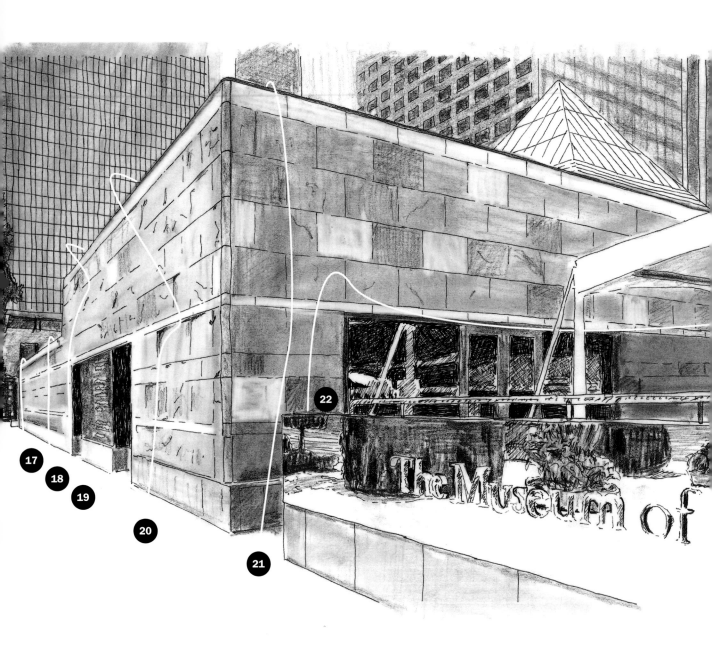

The Museum of

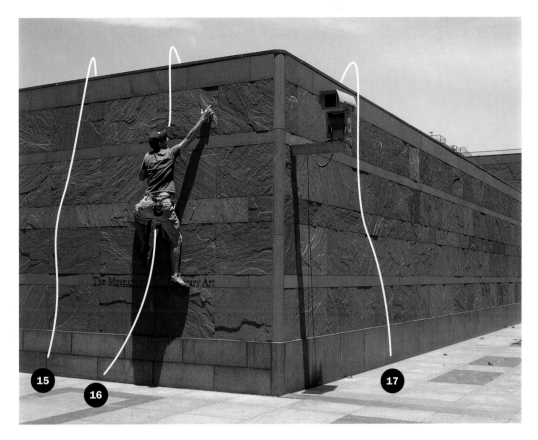

MUSEUM OF CONTEMPORARY ART

People say this is a great building, but they know nothing.
A varied quality container at best, normally holding only marginally
higher quality contents. Many short balancy routes that are only
climbable due to the shoddy uneven installation of the stone
cladding. Small edges, smears and splitting details offer a
large expanse of face routes.

"No person who is not a great sculptor or painter can be an
architect. If he is not a sculptor or painter, he can only be a
builder[er]." John Ruskin.

APPROACH

Diagonally opposite Disney Concert Hall on the south side of
Grand Ave.

SOUTH FACE

15 MOCAMADNESS V5 16ft SD ★★★

Right slanting route, start 20ft to the left of the south east corner.
Hard crimps to get off the floor.

16 MOCASIN V2 16ft

Right from Madness, 11 tiles from the corner. Two moves to finish.

EAST FACE

17 MOCACHINO V2 19ft ★★

Harder than it looks, start 12ft to the right of the security camera.
Left slant, crank for the lip from the undercling.

18 MOCAMERICANO V3 16ft

Right from Chino. Use the left slanting fingertip seam.

19 DOUBBLE SHOT DECAFF V4 16ft ★★

From the left hand doorway, stem up then transfer awkwardly
to the face.

20 MACCHIATO V6 24ft ★

Three tiles to the right of the second doorway. Razor seams
and one small edge. Move right before going back left again.

NORTH FACE

21 GRANDE FRAP V4 24ft SD ★★

Layback the corner from seated to the lip.

22 SKINNY LATTE V8 54ft ★★

Balancy traverse along the length of the north face above the
fenestration. No lip.

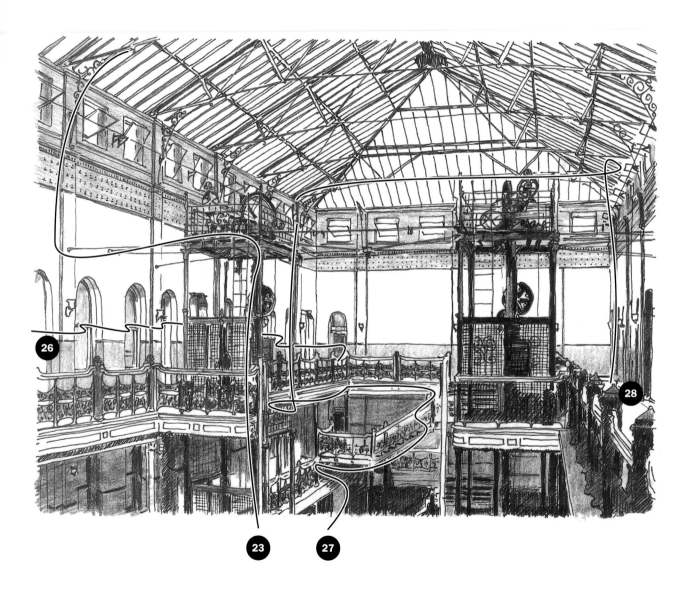

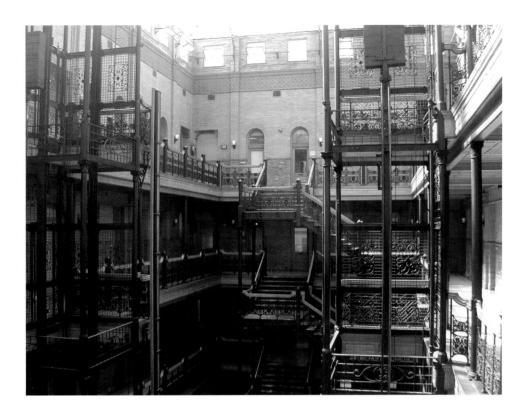

BRADBURY BUILDING

Sebastian's leaking building from *Blade Runner* is a structure from the cast iron age of Eiffel and Labrouste. The bland Romanesque Revival of the exterior offers little of any interest, and no routes of any real quality. It also gives no clue to the treasure hidden within.

"A vast hall full of light, received not alone from the windows on all sides but from the dome, the point of which was a hundred feet above.... The walls were frescoed in mellow tints, to soften without absorbing the light which flooded the interior."

So read the 1880s Si-Fi novel that Wyman, the Bradbury's eventual designer, was reading whilst working in his uncle's architecture firm as a draftsman. To cut a long story short, that's what he built, after being chosen by Bradbury with the help of an Ouija board, (Bradbury in turn died just months before his building was completed). 100 years later Ridley Scott returned it to what it was originally meant to be; "a building from the future designed from the past". Spooky....

APPROACH

Broadway and 3rd.

23 NEXUS 6 5.9c 197ft *

Straight up the exposed east face of the west elevator shaft.

24 DECKARD 5.10b 215ft **

As for Nexus, but continue up onto the top of the elevator shaft, traverse right on steel tension cable to wall and up to roof lights.

25 REPLICATOR 5.9a 197ft

The slightly easier variant of Nexus, up the east elevator.

26 SEBASTIAN'S ROOM V4 95ft **

Traverse the doorways and windows on the upper level using the dado rails and window ledges

27 ATTACK SHIPS ON FIRE OFF THE SHOULDER OF ORION 5.10c 345ft *

Move up the outside of the stairway, hand over hand until you reach the first iron column. Ascend this to the next landing, and again move up the outside of the stairs. Up one more column to the upper balcony and traverse to the lift shaft, from here up to the lift gear.

28 TIME TO DIE 5.12b 115ft

Not for the feint-hearted, bridge the northeast corner to the cornice detail. Traverse to the skylight crossbrace over the central well.

SHITCRACK

As much a part of downtown as Staples Center and the Standard's rooftop pool. The home of the homeless.

"Someday a real rain will come and wash all this scum off the streets."
T Bickle

Not in LA it won't.

APPROACH

4628 Pico – look for the human excrement.

SOUTH FACE

29 SHITCRACK 5.9c 46ft **

Step over the piss and shit and hold your breath through 40ft of stinking lieback. It's really unpleasant getting off as well.

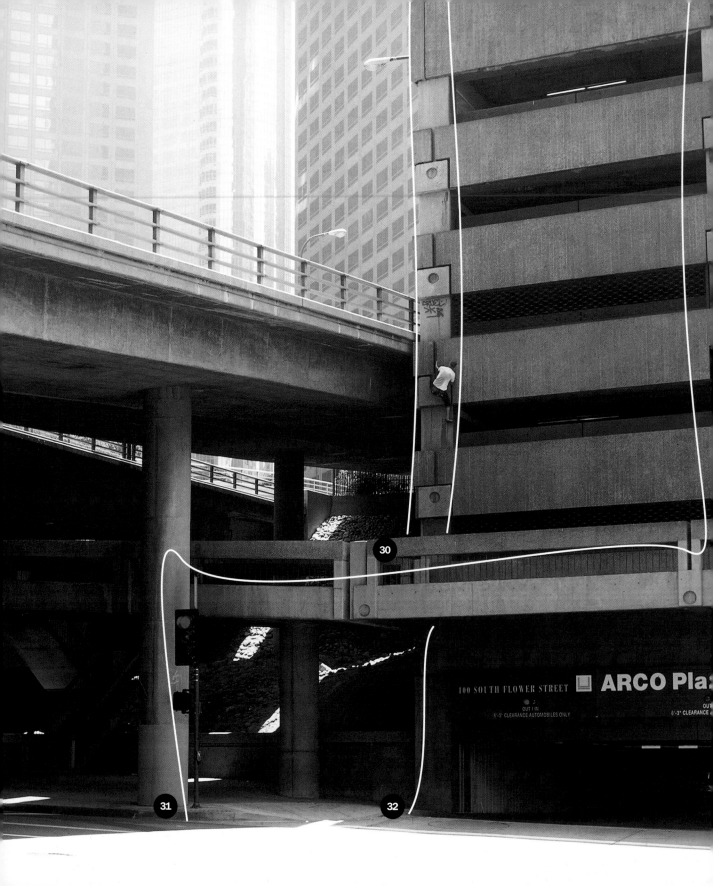

100 SOUTH FLOWER STREET ARCO Pla

OUT / IN
6'-3" CLEARANCE AUTOMOBILES ONLY

OUT
6'-3" CLEARANCE

30

31

32

ARCO PARKING

Dirty and smelly like so much of downtown, and with few reasons to recommend itself. These climbs do at least offer an amazing view, especially as you pass out of the dank shadow of the freeway, only a few feet from the speeding cars. Lazy pseudo-modernist detailing offers good foot holds with an easy walk off through the garage.

Watch for loose pigeon-shit build up on the ledges.

APPROACH

Flower St below the 110 4th St exit.

30 PLAZA PARKING DIRECT 5.9a 75ft *

As the name implies, Start on the higher level of the walkway and go straight up the northwest corner. Easy hands and feet, except for crux hand/finger jams to final summit.

31 CRASH 5.11a 95ft

Horrid lunging-stemming moves between the overpass column and the traffic light get you to the raised walkway. Cross this and hand traverse rightwards 30ft, then up the central supports to the heavens.

32 OFF RAMP 5.10b 115ft **

As with the Direct, but start at ground level and pass under the walkway.

BADA BING!

"At times during the climb [the Central Pillar of Freney].... Our one ambition had been to get off alive... but having completed it successfully we quickly forgot the discomfort.... We remembered only the pleasure of climbing warm, rough granite in magnificent situations, the beauty of the view and the intense excitement of searching for a route where no one had been before."
Chris Bonington

So, not much like Bada-Bing! then.

'Decorative' crazy-paving wall cladding, fixed for no obvious reason to a section of wall on a grim and scary downtown side street.

APPROACH

Pico and 3rd. Plenty of parking because there's no possible legitimate reason to be here.

33 UNCLE JUNIOR V0 11ft

Pointless really, just a fast way of getting really dirty and quite possibly having your life threatened. Ridiculously easy moves to the overhang, with one heel hook mantle to the shelf.

34 GOT YOURSELF A GUN V2 11ft SD

Marginally better than Junior. Climb the horrid, oily sharp right edge of the rollershutter from seated. Lunge for the overhang, then mantle. Don't hang around.

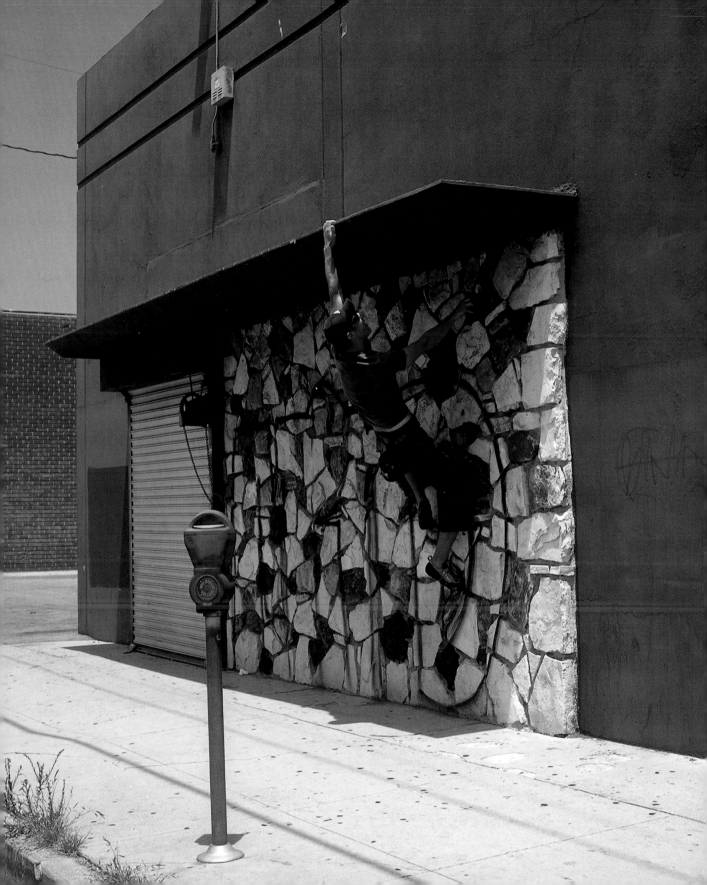

LA CLIMBS
DOWNTOWN

CHINATOWN

HOLLYWOOD HILLS
HOLLYWOOD
WEST HOLLYWOOD
SILVERLAKE
EAST HOLLYWOOD/LOZ FELIZ
WILSHIRE
WESTSIDE/BRENTWOOD
EAGLE ROCK/GLENDALE/PASADENA
MALIBU
LAX/WATTS
PALM SPRINGS

New Chinatown covers the 16 square block area north of
El Pueblo along Broadway and Hill St between Sunset Blvd
and Bernard St. The entire community, established in the
late nineteenth century, was forcibly moved to this site in the
1930s to make way for Union Station. As a buildering area it
has remained almost totally undeveloped. There are many
varied two- and three-storey buildings – with rare overhanging
roof traverses.

CHUNG KING ROAD

DRAGON GATE

200m

1000ft

CHUNG KING RD

This pedestrianized street, one block west of Hill St has been entirely colonised by overly hyped piss-poor art galleries, all of which have embraced the relaxed grunge aesthetic to such an extent that it seems they can hardly be bothered. This art colonisation results in a feeling of a themed mall. The up side is that the street remains largely deserted, and the signs and mixed architectural styles make for great traverses and a few nice short routes.

All walk offs are sketchy and involve drain pipes at the south end of the street.

APPROACH

Leave the 110 Fwy north of downtown at Hill St.

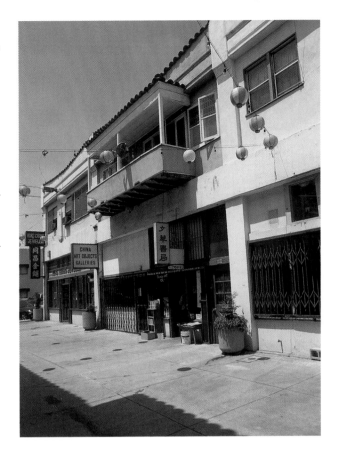

35 GREAT WALL V4 235ft **

Both east and west faces of the street will go as traverses. This, the longer west face is really enjoyable and sustained. The grade changes if attempted in the day with the security grills withdrawn (V5+). Start at the south end of the street on the fenestration of Hong Chong Jeweller, and go no higher than 10ft from the ground.

36 FORGET IT JAKE 5.11a 43ft

Start at the left-hand corner under the China Art Object sign. Straight up past a tricky bulge to the overhang crux. The route uses the far-left horizontal support beam of the balcony, and then goes well within the grade up to the roof.

37 J J GITTES V4 165ft *

Shorter and less consistent than the Great Wall, start at the south end, traverse the east face to the first corner. Remain low.

38 HOLLIS MULWRAY 5.11a 45ft

Opposite Forget It Jake on the right glazed frontage of Mary Goldman Gallery. A direct line to the roof, with two hardish moves.

39 HAPPY LION V5 25ft **

The crux only of Great Wall. Start down the alley and traverse around the frontage.

40 ELECTRONIC ORPHANAGE 5.12b 115ft

Let me know if you can work out the function of this gallery space, as I never did. Climb the right dividing column between this and the next gallery. Hard and exposed into the overhang.

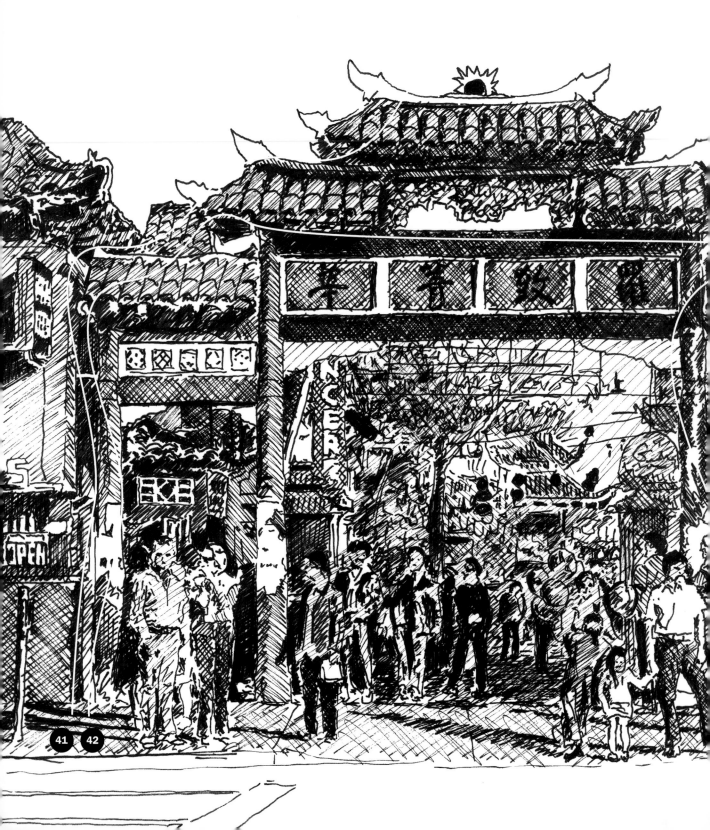

DRAGON GATE

This area still remains largely ignored by local builderers. There are some good varied routes here, and one of Los Angeles' best bars, Hop Louie, is close at hand as a hasty retreat if required. Quite possibly the only place in LA you can climb 5.11 on a Chinese pagoda, and then go inside it for a drink and a smoke.

APPROACH

East side of Hill St between Bernard and Alpine.

41 ST GEORGE 5.10a 48ft

Climb the off-width gap to the left column, bridge to the overhang, traverse the tiles, mantle twice using the decorative pig/sword/torch things to reach to top.

42 SUPERIOR POULTRY V4 65ft **

Named after the only place in LA you can choose the bird you want to eat, and then have it dispatched in front of you. As for St George, climb the left column to the second overhang. Traverse right below the eaves across the large writing. Descend the right column.

HOLLYWOOD HILLS

Given the chance, who wouldn't want to live here in the hills? High above the scum, as the glistening city stretches out below you to meet the ocean. If Los Angeles is about anything, it's about segregation and privilege. There are more exclusive areas to live – but in Malibu you'll end up wearing calf-high white socks with open toe sandals, sharing a gated community with your fellow mega-rich. In the hills, there's still a vague chance to be an individual.

Unfortunately there are the earthquakes to worry about as you sit projected over some canyon on two cantilevered beams directly below your neighbour's experimental under-engineered top-heavy monopod house.

HOLLYWOOD SIGN

CHEMOSPHERE

FITZPATRICK HOUSE

GARCIA HOUSE

200m

1000ft

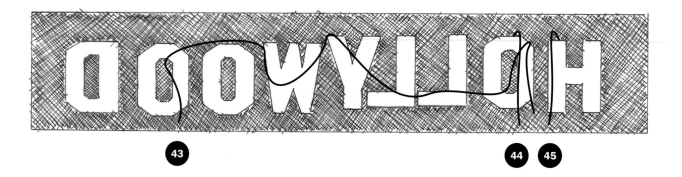

HOLLYWOOD SIGN

Ten years after erection, in 1932, actress Peggy Entwistle threw herself off the H, forever linking the name of this town with shattered and failed dreams. At various times the H and an O have toppled down Mt Lee, forcing the city to eventually take guardianship of the sign. They later removed the final four letters of the original "Hollywoodland" real estate hoarding, and have fenced it off to prevent access to pranksters, tourists and suicides.

Until 1939 a caretaker living behind an L watched over the sign.

Nowadays, if you were to reach the top of any of the letters and find yourself wondering what those small hi-tech round black things are, then it could well be too late for you – as they're cameras.

APPROACH

Bizarrely hard to actually locate for an object that's impossible to avoid as Los Angeles' most recognisable landmark. Head up Beachwood to Mt Lee, or hike the access road from behind....

43　OOWYLLO 5.11c 375ft **

The D and H sit lower on the hill, and as yet have remained unlinked to this traverse. Start on the last O and connect the letters, maintenance ladders are off. Scary exposed leaps to razor sharp edges provide little in the way of entertainment. Crux between the offset W and Y.

Not yet done in reverse order (L to O).

44　THE BIG O 5.8 55ft *

All the vertical I-beam supports go at this grade, although the first O is less exposed to observation cameras and feels easier to run away from. Use no ladders.

45　DYSLEXIA 5.10b 55ft

Like a gaint labber, use the shrap U sectoin horizotnals to moev up the reer left ebge of the H. Full raech moves and tircky balancy stuff to gian aech rung.

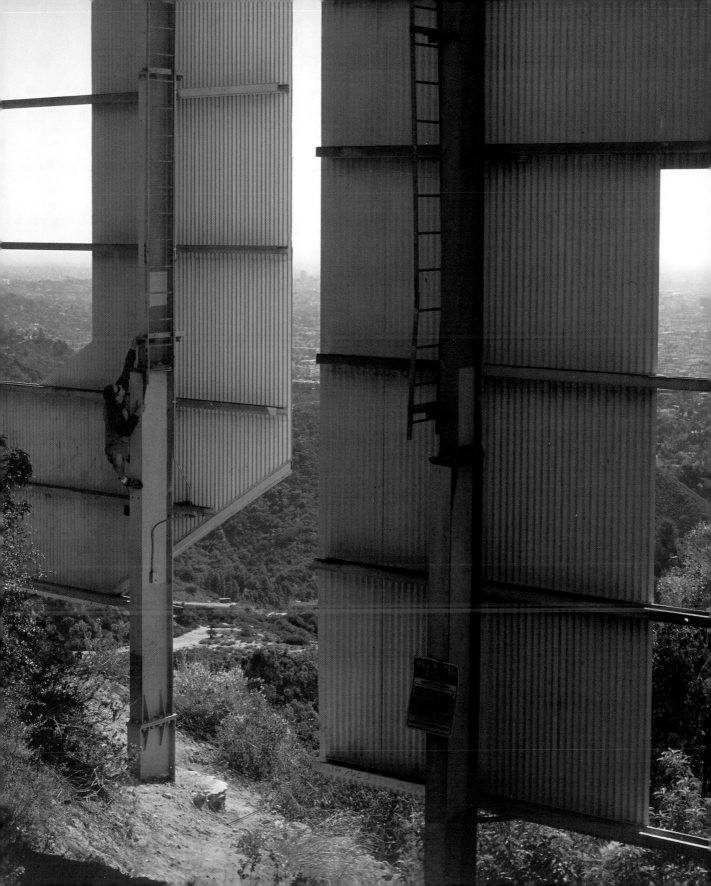

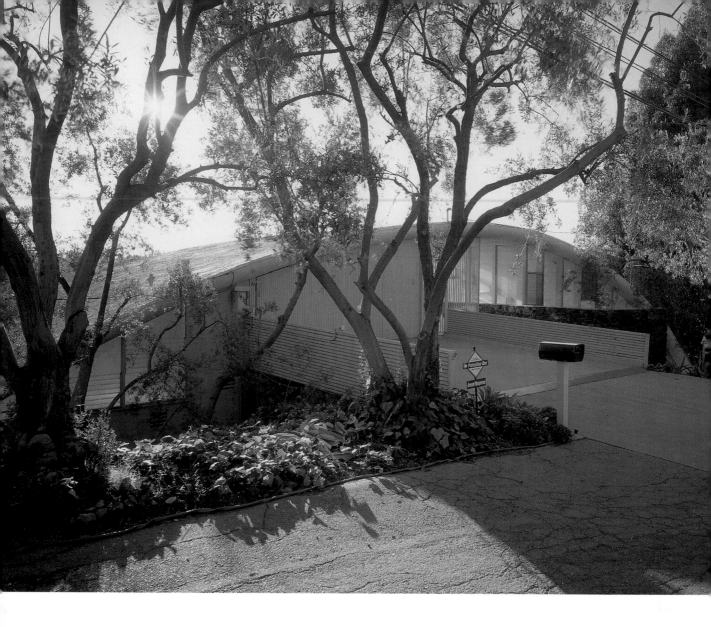

GARCIA HOUSE

This has to be one of the finest and most underrated pieces of domestic architecture anywhere. Resulting from a fantastic solution to another difficult steep site, it's a fraction too public for my liking, but provides long and exposed hand traverses on both faces, with several gnarly overhung routes up the steep drop off of the south face. Quintessential Los Angeles views to the ocean after summiting.

Bizarrely, Richard Donner made an exact replica of the house, so that Mel and Danny could shoot it up and pull it down in the wholly unnecessary *Lethal Weapon 2*.

APPROACH

Northwest of Runyon Canyon Park.

46 CYCLOPS 5.10c 75ft **

On the south face take the awkward first angled support beam, up to the structure below the house. Traverse the underside of the stairway to the balcony and hop up. Move up the ascending fenestration details to the large overhung roof section. Ease yourself out using the internal glazed corner and slap the sloper of a ledge.

47 MYOPIC 5.11a 126ft *

Climb Cyclops to the stair and take the fat eyelid lip all the way up and over. Several sections are pumpy hands only, but there's just enough for feet to make it do-able.

48 JERRY 5.10a 54ft **

A nice route in that you don't spend the whole time thinking you're going to die. On the north (road) face, hand traverse the eyelid with lots of options for feet.

49 BLIND, BLIND, BLIND V3 29ft

From below the garage connecting bridge, move rightwards and onto the stonework detailing. Take this all the way to where the ledge slopes down to meet it. Layback the ledge to find the top.

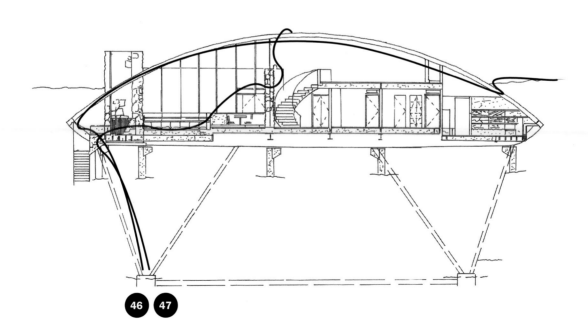

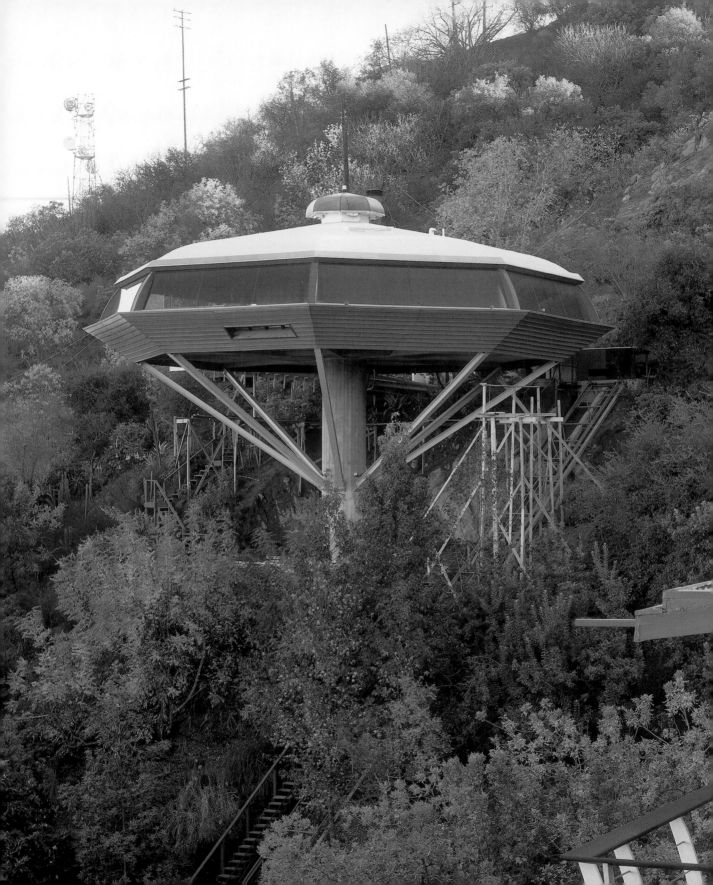

CHEMOSPHERE (MALIN HOUSE)

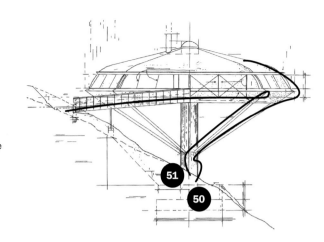

Iconic and spectacular. Lautner's house, now owned by Taschen hovers above the treeline with panoramic views over the valley below. Malin, the original owner, didn't fancy yardwork and so was happy to be perched amongst the tree canopy leaving all that leaf sweeping and plant watering to others below.

The site came cheap as it was deemed impossibly steep to build on. At once futuristically stylised and somehow nostalgic, the house manages to always look serious.

Hard moves to access the support beams, with the crux dyno moves through the wooden siding overhang. Major exposure and hard to protect.

New trying-to-be-sympathetic, though-possibly-dodgy building works are being attached which may well provide new routes.

APPROACH

Off of Mulholland.... Just drive until your car cuts out, piercing bright lights beam down from above, and several unaccounted for hours pass by; leaving it curiously hard for you to sit comfortably for any sustained length of time.

50 LANDED (AKA ABDUCTED) 5.10c 95ft **

As for UFO variant, take the support beam to the right of the inset window. Use this to gain the sharp edge, and traverse the overhung lip to the walkway. Move down before the door, and meet the hillside from the underside of the ramp.

51 UFO 5.13b 75ft ***

Start at the highpoint of the base column and reach for the easiest diagonal support. 'Walk' up the beam (or dangle below it). One hand undercling the wooden siding whilst moving up the 60 degree overhang as far as possible, fire out and up for the sharply defined lip and don't miss. (5.10c if you use the window cut in the panelling.) Hop up to the top.

52 EVIL PUBLISHING GENIUS
ATTEMPTING WORLD DOMINATION 5.10a 54ft **

If the lift cage is fully up at the top of the hill, and not down by the driveway, climb the cage and bridge to the overhung siding. Heel hook mantle to the ledge, then crimp the upper window frame and gain the roof.

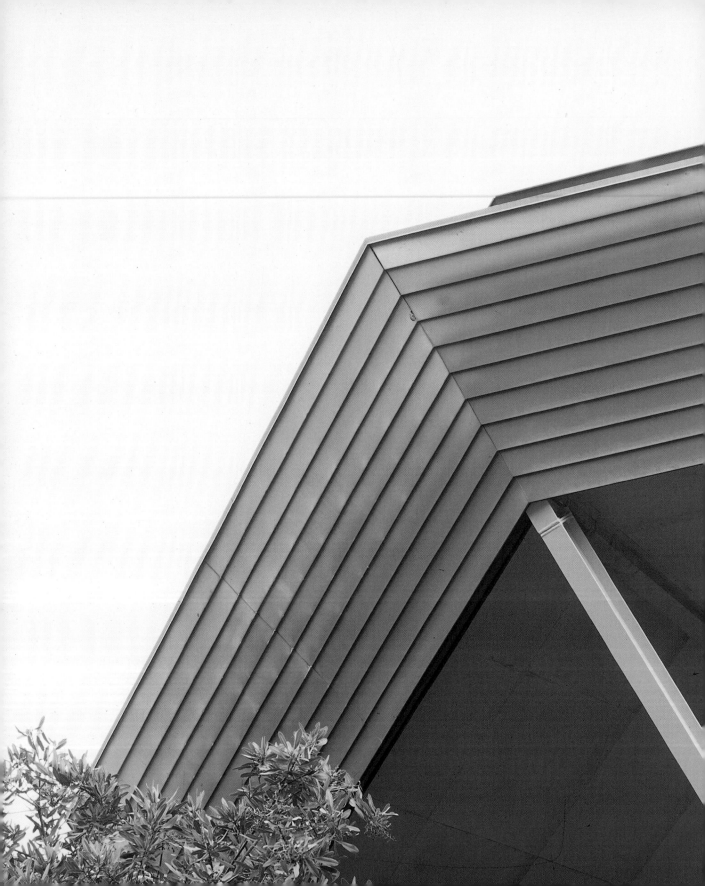

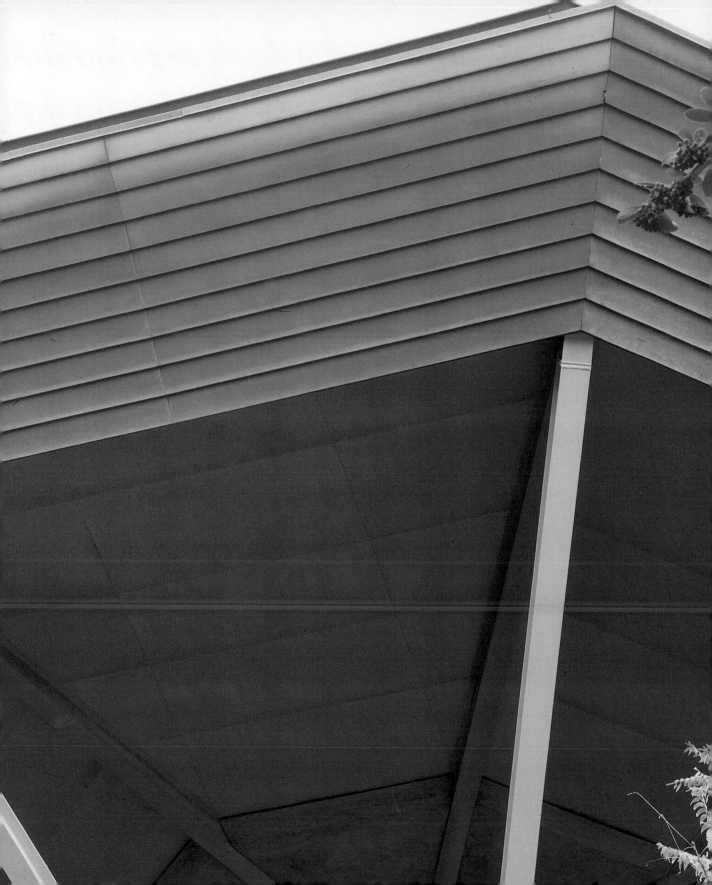

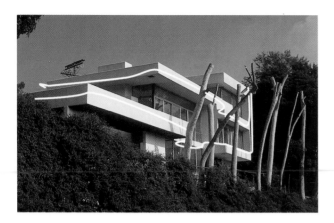

FITZPATRICK HOUSE

With its strong horizontal volumes, Schindler's 1936 white stucco house folds back into itself. The southwest face follows the line of Laurel Canyon below, with the other half of the house merging into it at right angles. These blocked volumes collide brilliantly, creating differing heights with multiple roof areas, terraces and balconies.

The newly restored home has stucco more abrasive than an off-width crack at Josh. Most climbs result in severe skin laceration and accompanying weeping open wounds. Blood on the whitewash is anti-social and hard to get off.

Due to the way the building sits so well into the hill, the traverses quickly become very exposed with long drop offs onto sketchy landings.

APPROACH
Woodrow Wilson.

53 IF THE CAP FITZ 5.12a 256ft *

Like life really; exciting at the beginning – boring in the middle – and scary at the end. Layback the left wall of the garage, difficult undercling moves lead to the long lip traverse around the west face. Drop to the upper balcony level and then layback the exposed vertical corner using the friction of the stucco.

54 LET THEM WEAR IT V5 24ft **

The first moves of Cap Fitz to the terrace traverse.

55 DEEP PAIN THROMBOSIS V6 16ft SD *

Layback to the overhang of the right hand garage wall. Difficult transfer move to the undercling hold, and crank for the terrace ledge.

56 BLOOD AND FIRE 5.11b 170ft

Traverse the lowest projecting walkway/balcony. Link to the glazing with feet on the dividing stucco seam. The crux section is the move from the glazing to the lower balcony in the left facing corner. Layback the southeast corner to finish as for Cap Fitz.

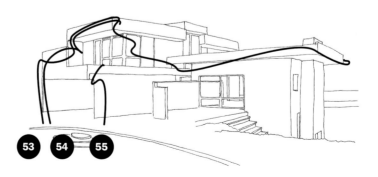

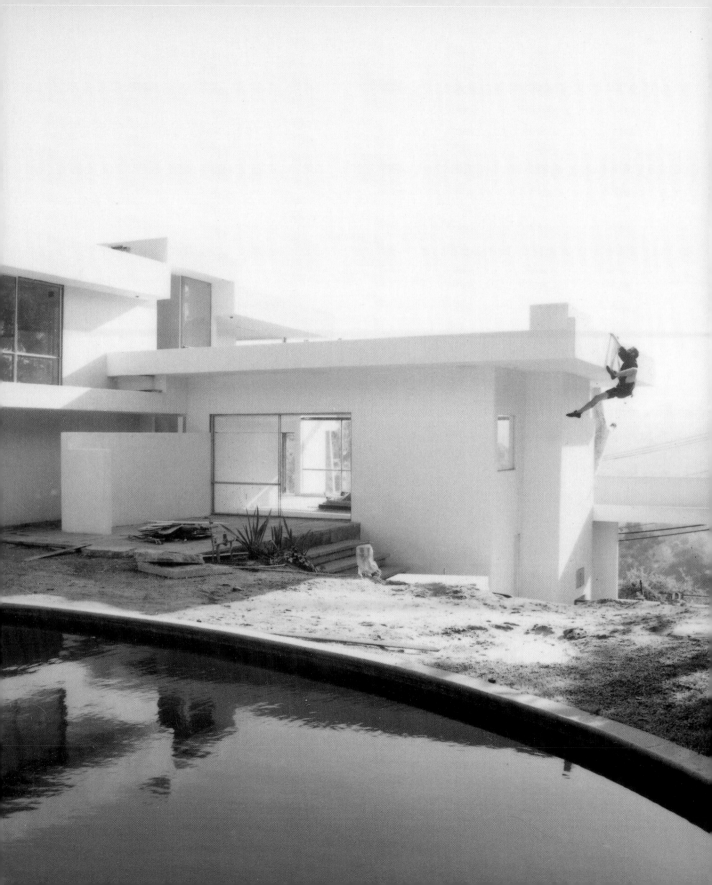

LA CLIMBS
DOWNTOWN
CHINATOWN
HOLLYWOOD HILLS

HOLLYWOOD

WEST HOLLYWOOD
SILVERLAKE
EAST HOLLYWOOD/LOZ FELIZ
WILSHIRE
WESTSIDE/BRENTWOOD
EAGLE ROCK/GLENDALE/PASADENA
MALIBU
LAX/WATTS
PALM SPRINGS

To those who've never been to Los Angeles, the word Hollywood doesn't immediately conjure up teenage runaways, junkies and general urban degradation. Angelenos, however, have long had to accept the area's slide gutterwards.

In the 1880s Mr and Mrs Horace Wilcox planned the development of Hollywood. They were determined that it would be a center of high culture and morality, and so offered a free lot to any church that would build here. When movies were first developed in

New York, they were banned here along with liquor and all other forms of vice.

Now being re-sanitised and overhauled for the tourist and with the street people largely moved on there's little reason for anyone who actually lives in the city to ever halt his or her journey here (excursions for piercing and tattoos excepted).

They're all looking at the stars and some of them are in the gutter.

HOLLYWOOD BOWL

666

GRAUMAN'S CHINESE THEATER

CINEMA

EL CAPITAN

DOWNTOWN MOTEL

CINERAMA DOME

200m

1000ft

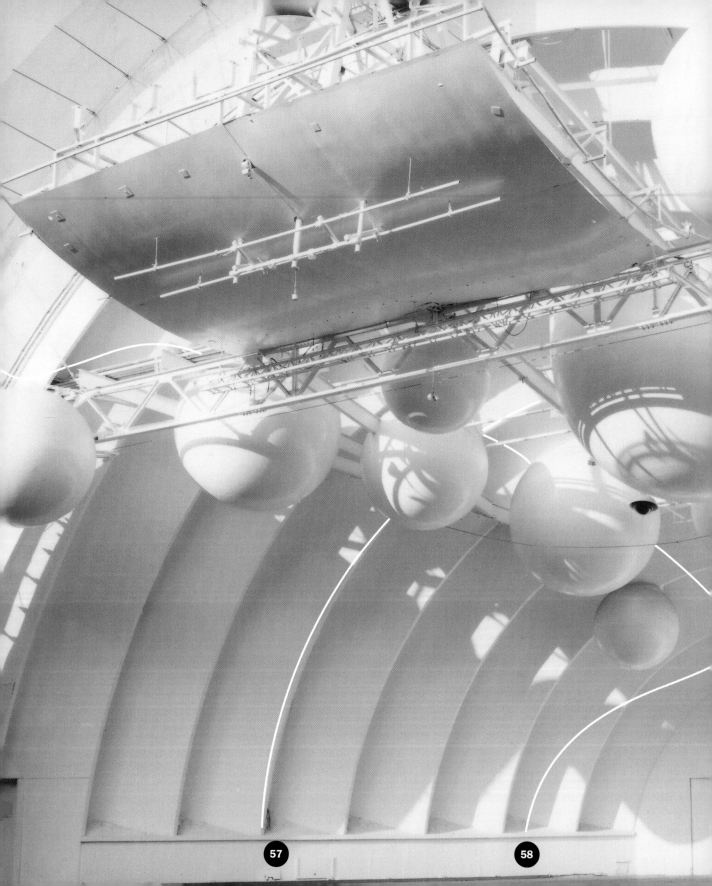

57 58

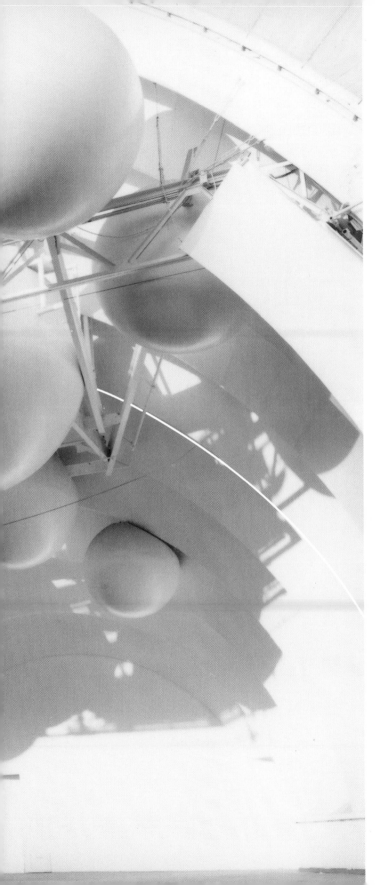

HOLLYWOOD BOWL

"When I am working on a problem, I never think about beauty...
but when I have finished, if the solution is not beautiful, I know
it is wrong."
R Buckminster Fuller

The temporary buildings first designed by Myron Hunt and then by
Lloyd Wright during the 1920s in the natural amphitheatre of Bolton
Canyon, are now replaced by the Frank Gehry 'renovation'. Routes
exist along the baffles of the shell as well as from the stagedoor past
the sound balls. The balls must serve some useful purpose, but what
that is and how they achieve it seems oddly hard to fathom.

APPROACH

Interstate 5 at Highland.

57 **TEN PIN** 5.11+ 83ft ★★★

A great route with loads of variation. Stem/chimney the sixth
largest waffle to the ball superstructure. Climb over this first
ball, across the tension cable and below the structural I-beam.
From here the route goes between the largest ball and the ladder
structure. Slot back into the waffle and descend the chimney.

58 **LEBOWSKI** 5.10c 106ft ★

From just inside the stage door, stem the waffle to the first ball.
Hard moves link this rear ball to the others. Move beneath the
roof to exit stage left.

GRAUMAN'S CHINESE THEATER

The showman, Sid Grauman's 2,258 seat theater was his sixth in Los Angeles. and was completed within a year of commission. It luckily survived modernisation, unlike his earlier Egyptian. Some believe Sid accidentally trod in wet cement during construction, and thus arrived at the idea of celebrity footprints.

Like all of tinseltown it's hard to figure out real from fake....
It's obviously not actually Chinese, but it isn't Disney concert-built particleboard either.

APPROACH

Hollywood and La Brea.

59 OSCAR 5.10c 125ft ★★

Hard to find a moment when there isn't an audience, this direct route moves up the inside of the left column to the pergola and then along the ridge to the eastern iron spike.

60 KING OF KINGS 5.13a 85ft ★★★

Four or five difficult pinch moves between each banding detail, with little for the feet, gets you to the metal crown below the final leadwork. Delicate and balancy the final moves offer great views and similar exposure. Named for C B De M's opening picture.

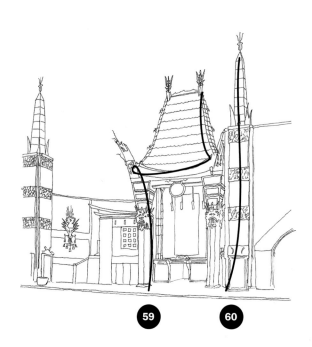

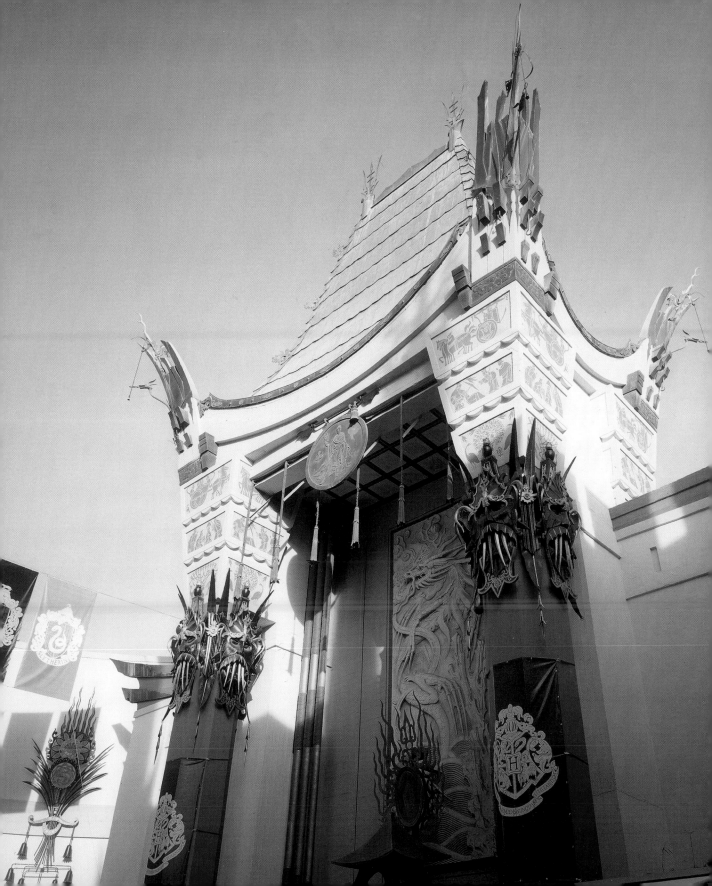

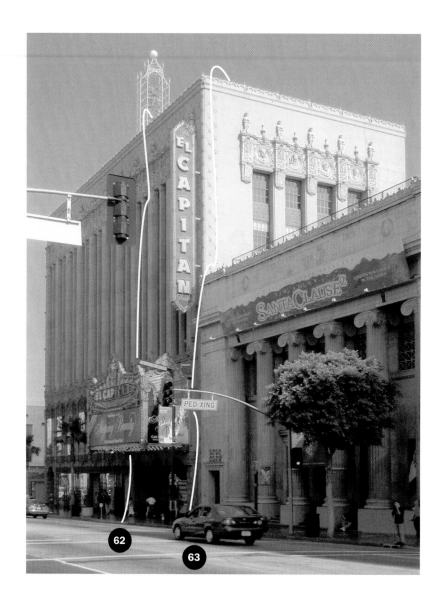

EL CAPITAN

Although not quite as imposing or legend filled as the eponymous rock. It nonetheless provides long and dirty routes, and so much more conveniently located for the shops than the valley (Yosemite not San Fernando).

APPROACH

Hollywood and Highland.

61 SALATHE WALL 5.13b or 5.10 A2+ 2900ft ★★★★

Royal Robins dubbed it "the greatest climb in the world", but then he makes those terrible clothes. Salathe's 35 pitches ascend the most natural line on the face. The aid cruxes are slightly trickier than those of the Nose, and with more mandatory off-widths.

62 THE NOSTRIL 5.11c 194ft ★★

Climb the decorative detail to the right of the box office. Climb past the canopy and stem to the illuminated sign. Easy satisfying moves follow the corner detailing to the top out. In these fast and light days, this can be done in one push – no portaledge required.

63 WALL OF THE EARLY MORNING BLIGHT
5.9 205ft ★★★

Take the entrance wall on the left and climb past the canopy. Move straight into the window systems above, and sustained stem to the decorative detail below the roof. Link to this through the small overhang and carefully move through the fragile holds to finish.

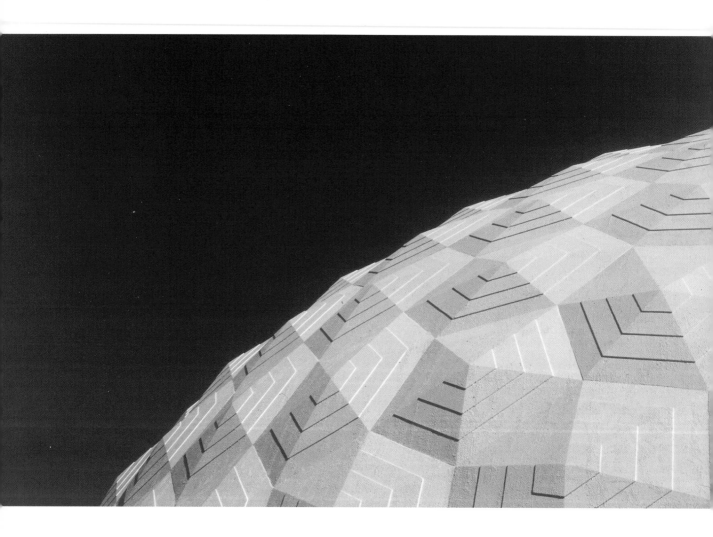

CINERAMA DOME

It's big, miraculous, concrete, geodesic and glorious.

Built in 1963 to show special 'Cinerama' movies, the Imax format of the early 60s. They used three 35mm projectors and a vast curved screen to present realistic travelogues. Initially it was a huge success with hundreds of other domed theatres planned, but the process proved too expensive, and the Cinerama fad soon faded. Now redeveloped, the dome itself is still magnificent, but its integration into the ubiquitous entertainment complex, complete with surrounding waterfalls and overbearing parking structure, has significantly lessened its impact.

APPROACH

Sunset and Vine.

64 **BUCKY** 5.9 128ft **

Just right of the box office ascend the vertical wall section, through the canopy to the dome. Hard down climb to the rear.

65 **TITLEIST** 5.9 195ft ***

Traverse the dome at its lowest most vertical section.

HOLLYWOOD DOWNTOWN MOTEL

Not much that you could do on the exterior of this building could ever compare to what goes on inside.

APPROACH

Sunset and Western.

66 VEHICLE IN BACK (DIE YOUR HAIR BLACK) 5.8 68ft **

Behind the bush and up the rock wall to the small overhang. Mantle and gingerly ascend the sign bearing in mind that 'high voltage' means exactly that.

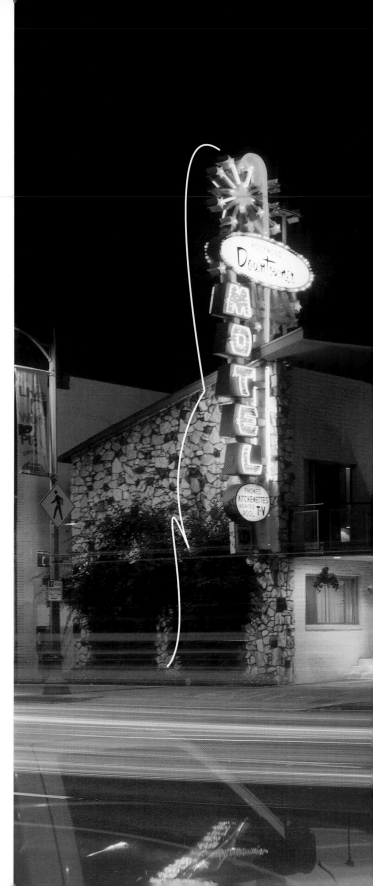

CINEMA

A forlorn location for one of those last man on earth movies.

APPROACH

Off the 101 at Hollywood Blvd.

67 OMEGA MAN 5.10b 42ft *****

Access the overhung roof via the boarded up face and
move across via the holes for the downlighters. Heel hook
to the advertising hoarding and up if you trust the horizontal
letter supports. The safer option is to move to the central joint
and either finish on the ladder or traverse left and up using
the end wall.

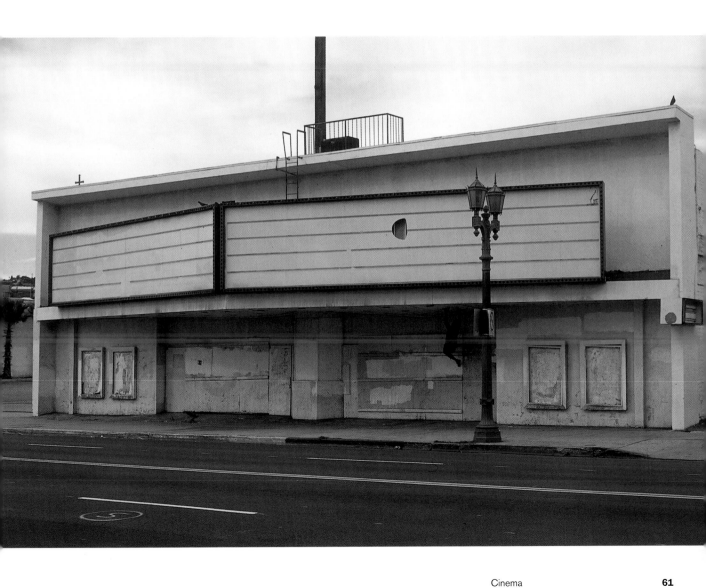

Cinema

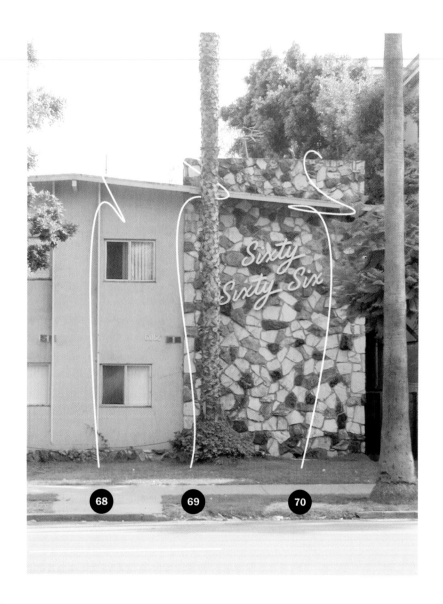

SIX(TY) SIX(TY) SIX

Beware large black birds/loud Latin-chant music/young starey eyed boy.

APPROACH

Franklin and Beachwood.

68 DAMIEN OMEN 1 5.10c 43ft **

Climb the weird, insecure vertical stick-on feature to the left of the windows. Try not to think of that bit in the movie where the glass slides off the truck and decapitates our man.

69 DAMIEN OMEN 2 5.8b 42ft

Take the left edge of the vertical paved patio and stem to the palm tree onto the roof.

70 DAMIEN OMEN 3 5.10b 42ft *

Easy all the way until the heel hook crux move and mantle through the overhang.

WEST HOLLYWOOD

"We should build our house simple, plain and substantial as a boulder, then leave the ornamentation of it to Nature, who will tone it with lichens, chisel it with storms, make it gracious and friendly with vines and flower shadows as she does the stone in the meadow."
Irving Gill

One-third gay, one-third over 55 and an eighth Russian Jewish. Presumably, if we drew a Venn diagram there would be some overlaps.... But, most queer senior immigrants are probably unaware that, in addition to Schindler, Aldous Huxley lived here and Irving Gill designed the classic, now destroyed, Dodge House on King's Rd.

CASE STUDY HOUSE #21

CASE STUDY HOUSE #22

SCHINDLER-CHASE HOUSE

WRIGHT HOUSE

200m

1000ft

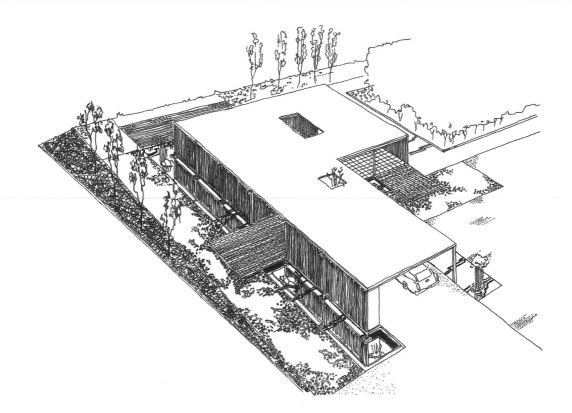

BAILEY HOUSE
Case Study #21

With its pure lines and nods to Japanese restraint, this monochromatic minimalist box really is an unbelievably beautiful house.

It was commissioned by a liberal psychotherapist, on one of only two racially unrestricted sites in Los Angeles. This integration policy was contested by the city all the way to the Supreme Court where the Baileys and Koenig won a groundbreaking exemption from the racist policies of the time.

Beautifully restored with the architect by a producer of *The Matrix* in 1997.

APPROACH
Lookout Mountain.

71 KEY TO THE DOOR 5.10c 43ft ★★
 Sustained hand traverse around the entire parapet/gutter.
 Passing over the moat, although hardly deep water soloing,
 it adds an incentive not to deck.

Bailey House Case Study #21 Piere Koening 1958

STAHL HOUSE
Case Study #22

It's difficult not to get an instant hard-on when standing poolside looking out over the vast cityscape to the sea. Quite simply the best house in Los Angeles, in the best spot the city has to offer.

APPROACH

Above the Chateau.

72 HEAT V6 56ft **

Test your pinch strength as you traverse under the roof overhang.

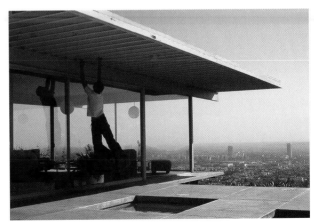

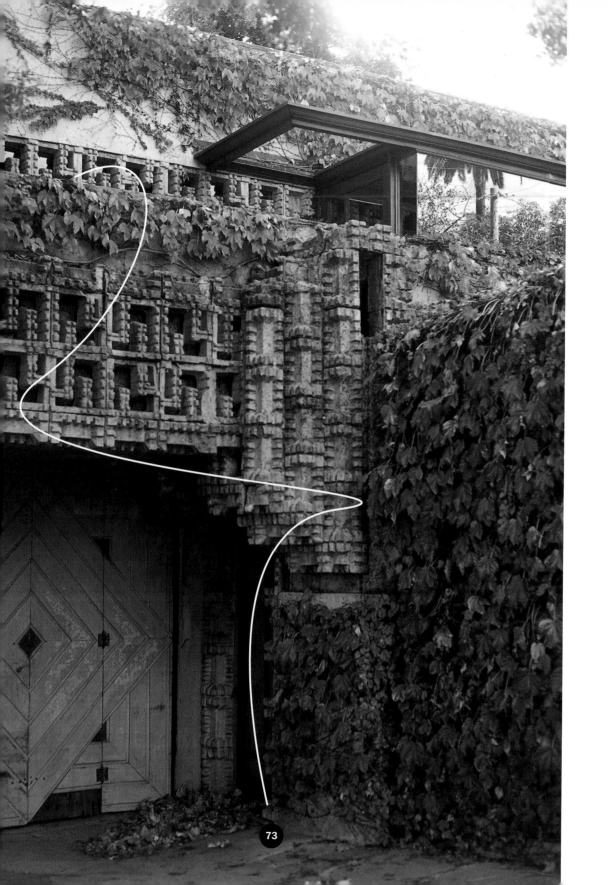

WRIGHT HOUSE

Lloyd's own house inspired by the Joshua Tree and incorporating fragile, decorative motifs of the cactus in the cast concrete blocks. These fine details are set off against the plain solid volumes of the house.

APPROACH

Below Sunset.

73 BLOCKY V1 18ft SD *

Up and under the doorway using the flaky cast block work.

SCHINDLER-CHASE HOUSE

Supposedly it's everyone who knows anything about anything's favourite seminal Californian modernist building. Uber-genius and occasional fruit-loop Rudolph arrived in Los Angeles to supervise Frank Lloyd Wright's Hollyhock House. Enamoured with camping and the outdoor life (an early Yosemite pioneer by all accounts, though no records of any climbing ticks exist), he built this iconic communal, two family, indoor/outdoor Japanese/Hispanic/craftsman shelter-house.

Sliding door/walls of glass and canvas open the internal 'spaces' onto garden and patios. The usual architect's guff about merging indoors and out really does work here in a magical way.

The design itself set the stage for Entenza's Case Study program, but the home-made campsite quality of the construction and his later move into idiosyncratic constructivism meant that he was never invited to make a house for the program.

The Chases eventually moved out and the Neutra family moved in setting the scene for collaboration and rivalry that now makes up a chapter in the history of modern architecture. The two families slept in sleeping baskets in the open air on the roof. However, when the Schindlers split the house was again divided in two, and his cuckolded wife put up pink wallpaper and carpeted her half to irritate the modern Meister.

Now an Historic-Cultural monument, it's open for tours and has a great book shop, but it makes a difficult venue for art and architecture exhibits which often just get in the way of one's enjoyment of the house itself.

APPROACH
Kings Rd.

74 CENTRAL CHIMNEY V4 64ft SD ★★
In the western garden area, sit start at the first concrete section. Round the corner and use the window slots to gain the chimney top. Finish at the northwest corner of the house.

75 LIST V3 34ft SD
Up under the overhang outside the office, cross to the west edge and mantle.

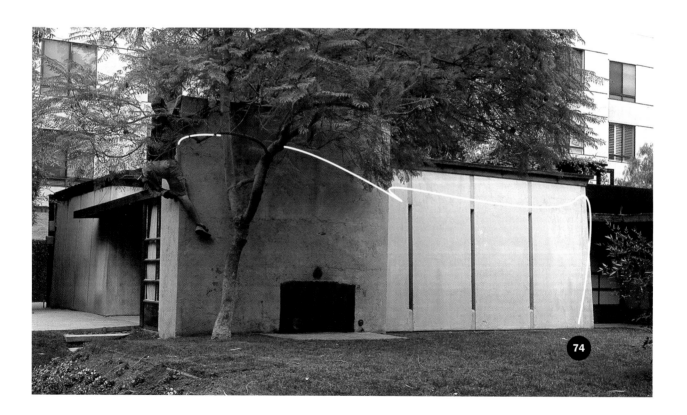

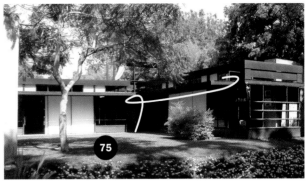

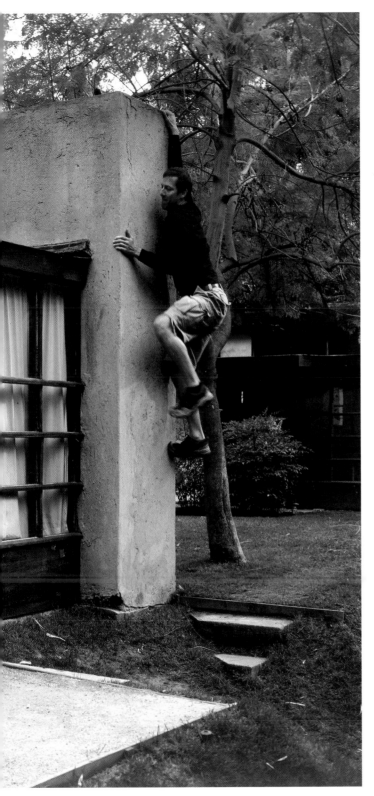

Schindler-Chase House R M Schindler 1922 **73**

SILVERLAKE

The hills surrounding the reservoir have provided the location for first rate architecture from the best Los Angeles Modernists. Once a bohemian neighbourhood, few artists can still afford the rents and gentrification is in an advanced stage.

Due to the lateral way the hills run through the neighbourhood, the area has resisted tract housing and as every sloping site is different, so the architecture is necessarily considered and individual. The reservoir and areas such as Sunset Junction provide focus for the community and a possibility to walk and not drive.

The dog walking pen – a squalid hugely crowded barren fenced area, stinks of doggy do, and along with Trader Joes, doubles as the area's most popular pick up point.

'SILVERTOP'

VDLII

OHARAH

HOUSE

200m

1000ft

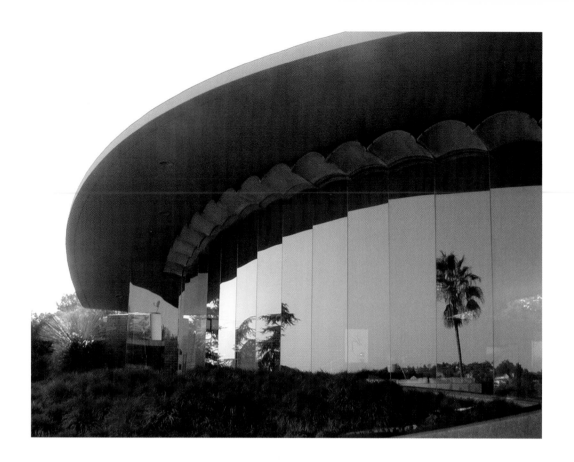

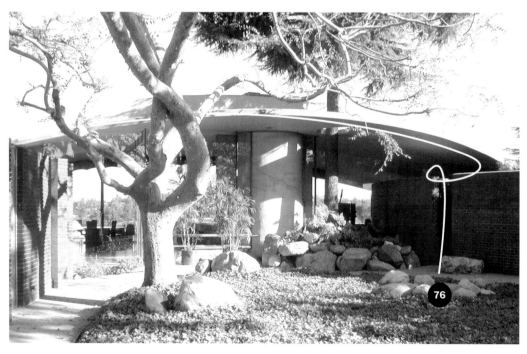

76

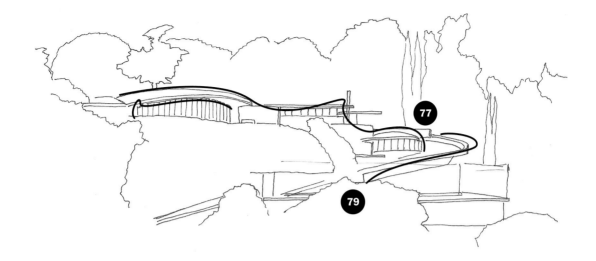

'SILVERTOP' (REINER HOUSE)

007 – Bond... James Bond.

Perched eerie-like above the reservoir, at once visible from everywhere, but somehow impossible to see (or find) from up close. Obviously due to the activated cloaking devise.

I've no idea how many evil geniuses Lautner knew, but who else could live in these houses? Beware, as certain suspension over a shark/croc infested pool awaits the captured.

APPROACH

In your Aston Martin.

76 LIVE AND LET DIE V4 95ft **
Stem up the portal in the South West garden wall. Link to the hand traverse below the shaped canopy over the bedrooms to the garage area.

77 DIE ANOTHER DAY 5.7 356ft
More of a scramble really, and Like Roger Moore – a poor relation of its predecessor. Start above the tennis court and use the roofs to finish at/in the swimming pool.

78 YOU ONLY LIVE TWICE 5.11 70ft **
On the reservoir side, traverse beneath the overhang using the fluted glass retainers.

79 GOLDFINGER V6 98ft SD *
Climb the sustained line beneath the driveway above the tennis court.

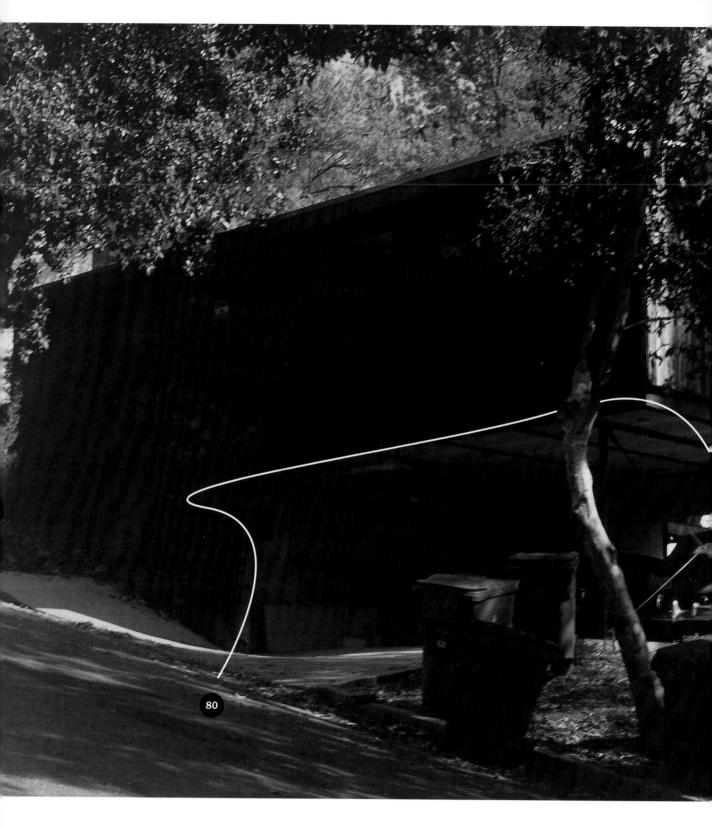

HOUSE

Nice house, nice vehicle, nice view.

APPROACH

Overlooking the reservoir from the west.

80 **BOXY** 5.10a 65ft ★★

From the shelter of the void space below the house, move up and right using the steel until you're below the window on the south face. Utilising the light fixing and window, mantle to the roof. Use any of the trees to descend.

OHARAH HOUSE

One of Neutra's own favourites, the house uses the gently sloping hill to dictate its volume with the master's characteristic extended horizontals shifting the axis and emphasis of the house towards the sparkling reservoir and its cool breezes.

Beautiful planting perfectly complements the simple structure.

APPROACH

East of the reservoir.

81 **SPOCK'S BRAIN** V3 62ft SD ★★★

From the southwest support post, move up and along the stacked volumes.

82 **LIEUTENANT OHURU** V2 56ft SD ★★★

Start as for Spock, but move left traversing the terrace.

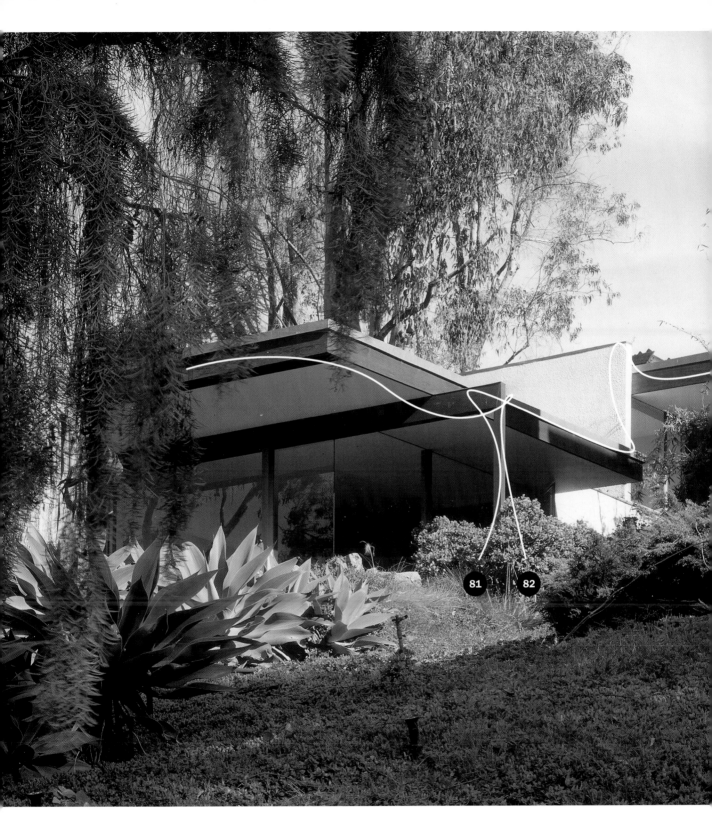

Oharah House Richard J Neutra 1961

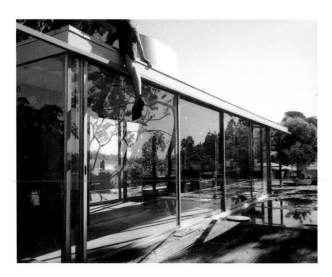

VDL RESEARCH HOUSE II

The original pure International Style Research House that stood here burned down in 1963. This building is much more romantic, shallow water pools make magic on every level, dissolving the structure from inside the house so as nothing of the now busy road interrupts the view to the reservoir.

Get on a tour, as you don't really get to see the miracle of how the spaces work either from the street or from any part of the exterior. Huge sliding glass walls turn inside to out and out to in. A really superb building.

The truest lines go up and over the front face, down to the courtyard and up again over the attached apartment to finish on the street behind....

The Neutras are buried in the courtyard, perhaps as wise insurance on the longevity and preservation of the property.

APPROACH

Silver Lake Blvd.

83 **STD** 5.10c 115ft **
From the support post by the front door, zig-zag across the different levels to the uppermost roof section.

84 **WWF** 5.10c 225ft **
Climb to the roof via STD, downclimb into the courtyard then up and over the apartment.

85 **WMD** 5.10a 65ft
From the internal corner of the house that forms the courtyard, gain all levels to the rooftop.

86 **JFK** V6 256ft
Moving behind the electric sunshades, traverse the house at first floor level.

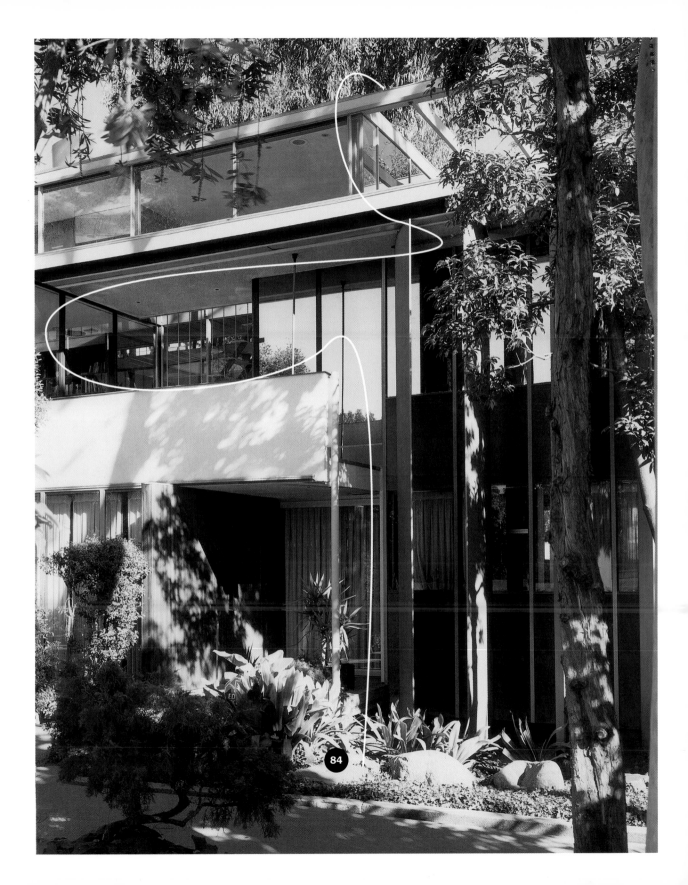

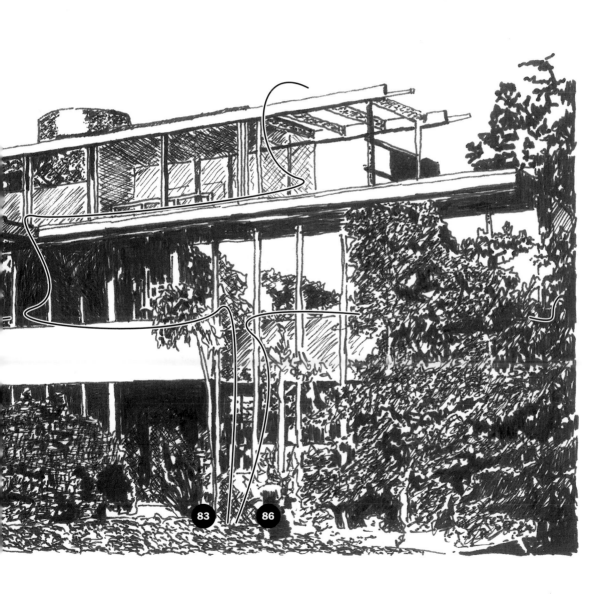

83 86

EAST HOLLYWOOD/LOZ FELIZ

Due to great chunks of the city visually emulsifying, an obsession has developed whereby every few hundred yards a neighbourhood is founded and a village declared. The irony of the improbability of these artificial boundaries will undoubtedly go unnoticed by most until they actually visit a village.

This said, Loz Feliz does seem to have a selection of stores that aren't all owned by major multi-nationals, and the proximity of two or more things of interest that could possibly be visited sequentially on foot rather than having to resort to motorised transport.

Southern Griffith Park also falls into this area, and as usual the city's fear of public assembly means that all access roads are disguised to look like they end with suburban armed security. The houses built into the Park have somehow managed to cunningly claim it as their own extended private garden, and this means that if you do get there you have the largest urban park in the world, complete with mini mountains, superb trails and fantastic views, virtually all to yourself.

GRIFFITH OBSERVATORY

LOVELL HOUSE

SAMUELS-NAVARRO HOUSE

ENNIS-BROWN HOUSE

SOWDEN

BARNSDHALL PARK

SCIENTOLOGY CHURCH

200m

1000ft

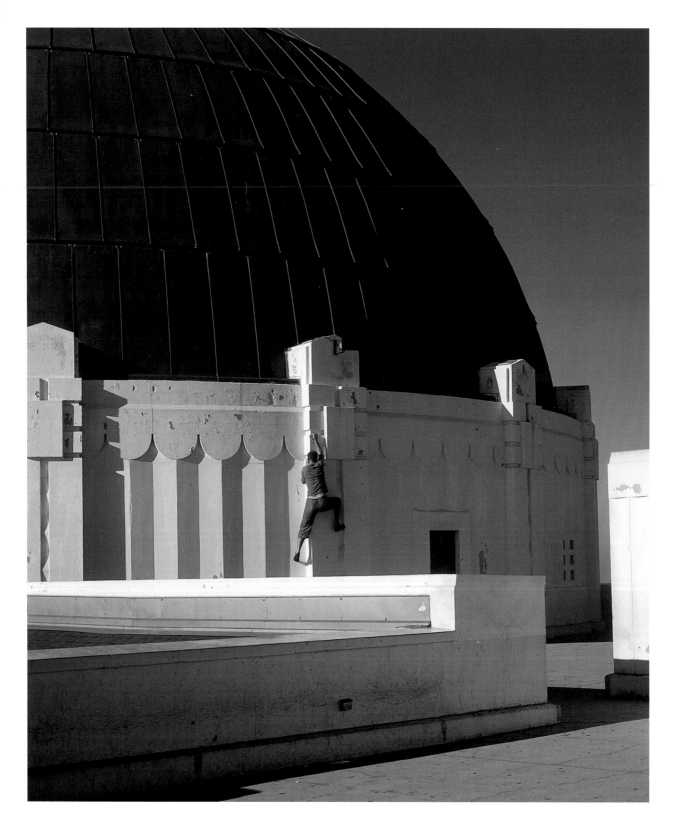

GRIFFITH OBSERVATORY

Wife murderer, (he shot her in the eye), and drunk Colonel Griffith W Griffith, gave the 4,000 acre Griffith Park to the city in order to beat the rap. In 1912 he gave truckloads of cash to build an observatory. Meanwhile some other Colonel also gave considerable amounts of money to build his own observatory, thus delaying beyond Griffith's lifetime the decision as to which telescope to build.

Architects such as Neutra were strangely passed over in favour of amateur astronomer Russell Porter. Eventually, luckily for tourists, romantics and location managers alike, they built the right building in the right spot with the right name.

Spookily, all three stars of *Rebel Without A Cause*, which was filmed here, died tragically in mysterious circumstances. Unfortunately for Californians, and possibly the world, Arnold "fuck-you asshole" landed here naked for the first time in *T1*.

Loads of climbs, from the obelisk out front to short and easy routes on the south face and longer, more exposed quite hairy lines up the buttress of the north face onto the domes.

APPROACH

In the park.

87 BIG DIPPER V2 165ft ★★★
Traverse the front face from side stairwell to side stairwell.

88 HASTA LA VISTA BABY 5.11a 112ft
Traverse the central dome either as a hand traverse using the upper ledge – great but little for feet. Or use the lower small ledge requiring big reaches and balancy side steps (5.10a).

89 PETER PAN 5.11c 124ft ★★★
Use the horizontal details on the building's front façade to gain the upper deck. On the central dome, move left out into space and gain the wide ledge from the first support buttress. Steep delicate face climbing with some bridging opportunities get you to the top. Down climbing is the hardest of all.

90 GALILEO 5.9+ 42ft ★★
On the obelisk out front, climb Galileo, the dude clutching the scope.

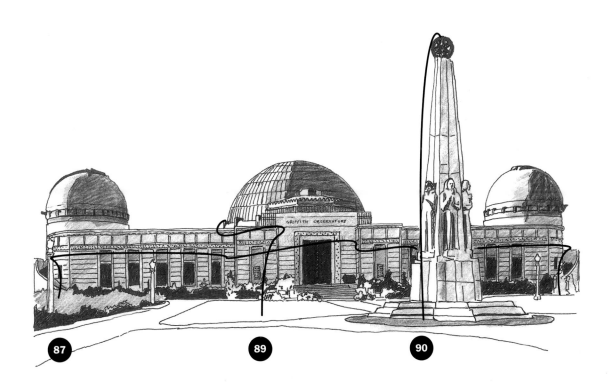

BARNSDHALL PARK

Undergoing total renovation the Park is, at the time of writing, shrouded behind chain link fence as the hillside is remade and the buildings made over. They all worked here, the Wrights, Schindler, Neutra....

Oil millionaire Aline Barnsdall gave the land to the city envisioning a Marxist style people park. It's still what Los Angeles needs most; public spaces, which aren't exclusively designed to exclude the homeless. It's no surprise that the lower parts of the estate have somehow been hived off for mini-malls and hospitals, and a large part of the restoration seems to involve losing the bottom of the hill to car parking.

APPROACH

Hollywood and Vermont.

91 TOWER OF BABEL 5.15+ 62ft ★★★★

Aie-je besoin de protections naturelles pour grimper cette voie en premier de cordée. C'est de la craie, utilisée pour l'escalade de rocher. Brauche ich ein Sechzigmeterseil für diese Route. Würdest du bitte auf mich aufpassen? Esto es material de escalada. ¿Donde se puede vivaquear?

92 BOB'S BIG BOYS 5.10c 76ft ★★

A ladder really, just with extremely tiny rungs. Crimps all the way up to the crux at the top where the detailing becomes vertical, and must be traversed for 6ft to reach the roof overhang.

93 TVC15 5.10b 45ft ★

Any of the columns supporting the canopy of the art gallery. As usual with these overhung roofs, the crux is in the move out to the lip.

94 GARDENING V2 165ft ★★

Fun juggy route as you traverse the hollyhock detailing.

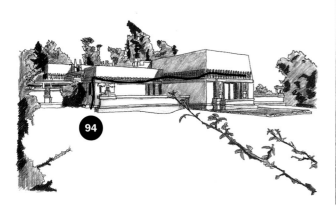

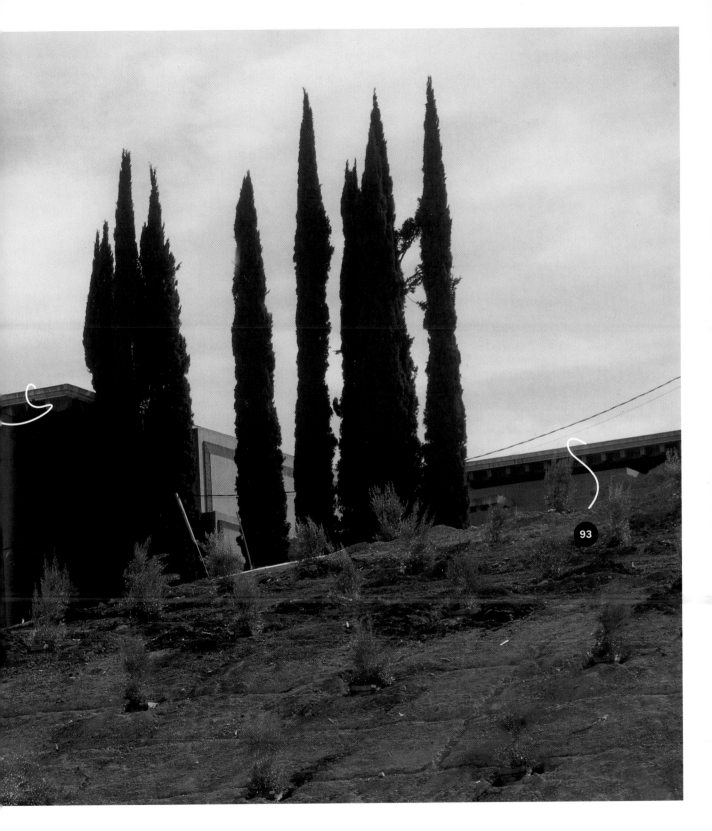

Barnsdhall Park Frank Lloyd Wright R M Schindler Richard J Neutra 1917-1920

LOVELL HEALTH HOUSE

Built on a steep hillside in the Los Feliz Canyon for the strange health nut Dr Lovell, who espoused naked sun bathing, bodybuilding, vegetarianism and healthful (?) communion with nature (not much changes round these parts).

This 'machine for living', along with Schindler's house for the same client in Newport Beach are the greatest monuments of the early International Style in Southern California. The three story house is entered on the topmost level, the balconies are hung from the roof frame and the concrete bands are supported on a lightweight steel frame, thus creating stunning volume and level changes.

Ironically, its main claim to fame of late was as smack victim and pimp, Pierce Morehouse Patchett's pad, in all time top movie – *LA Confidential*.

A true classic of modern architecture with OK routes too.

APPROACH
Below the golf course, jutting into the park.

95 OFFICER BUD WHITE 5.14a 95ft **

Reach the roof plane via the southwestern corner. Adjacent to the pool, shimmy up the corner post. The hard moves come as you cross each stucco banding. Use the top balcony to top out.

96 ON THE QT 5.12c 183ft **

Take Bud White to the middle band and then traverse left all the way to the back of the house using the window verticals.

97 SGT JACK VINCENNES 5.11b 124ft *

Start at the front door and move left along the sill at waist height. At the edge of this stucco section move to the corner using the fenestration. Continue westwards over increasingly exposed territory. At the entrance to the top balcony mantle up and use the corner post to access (with a dyno) the roof.

98 CUT TO LOOK LIKE STARS V2 12ft SD

This short line on the east face runs up the left side of the door. If the short dyno to the roof is too much, traverse left to lower section and mantle onto top.

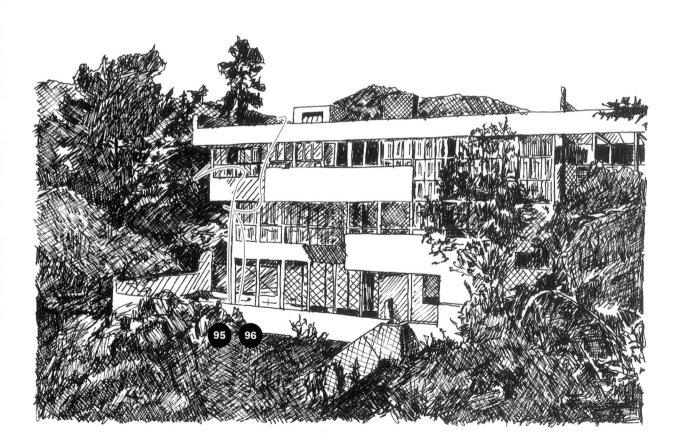

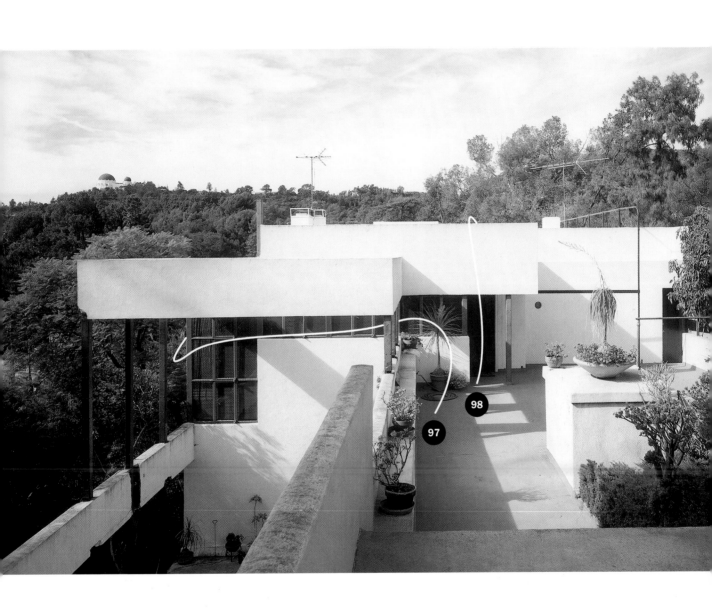

Lovell Health House Richard J Neutra 1929

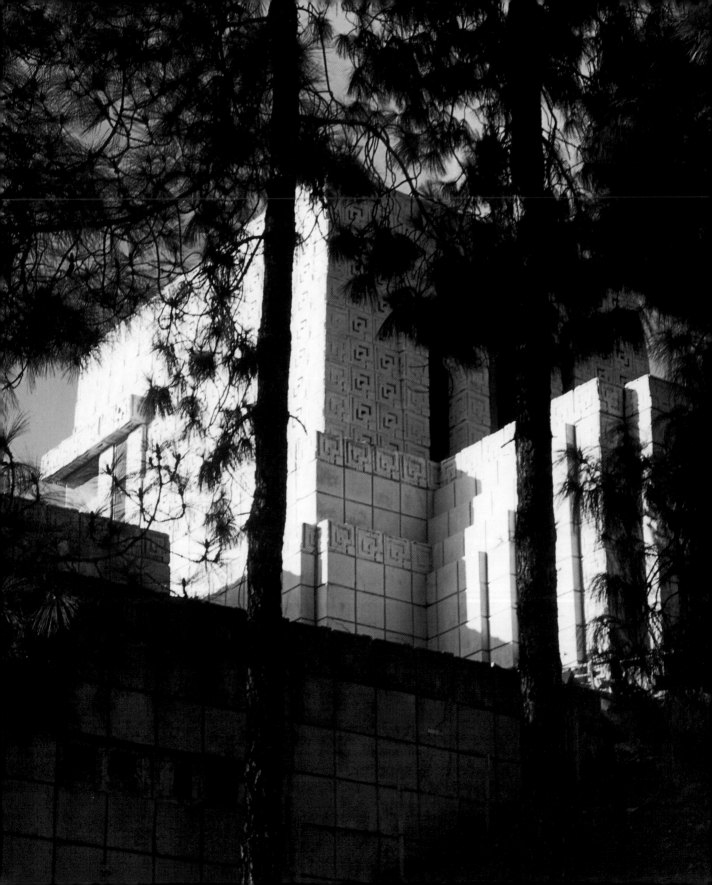

ENNIS-BROWN HOUSE

The mausoleum like Ennis house, was my first Wright climb. Although it does not compare to the truer lines on his 1919 Hollyhock House or indeed the four star classic Fallingwater, the division of its exterior and interior faces into smooth and patterned blocks makes for interesting and varied holds. This is the largest and last of Wright's concrete precast block houses.

It is undergoing slow restoration, but its ruinous state somehow suits the Mayan temple concept. Two loud and scary looking guard dogs roam freely inside and guided tours take place at 11, 1, and 3pm.

The interior was creepy Dr Eldon Tyrell's (death)place in *Bladerunner*.

APPROACH

North above Vermont Ave.

99 DO THE WRIGHT THING V3 30ft SD **

Crouch under the left side of the pedestrian doorway; pull up from seated onto column and then to horizontal line. Traverse brickwork for 20ft to below guard dog house. Beware loose brickwork.

100 INCAN IMPRINT/AZTEC ARRANGEMENT 5.10a 60ft *

Start on the inside of the pedestrian gate, traverse south across the terracing over the doorway, and then up the diatheral to the roof.

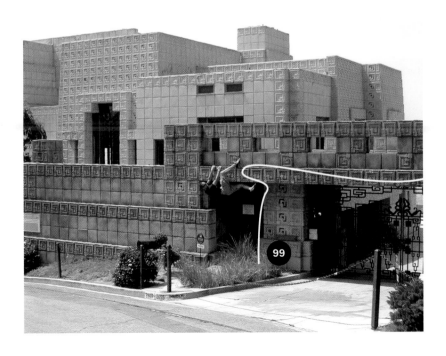

Ennis-Brown House Frank Lloyd Wright 1924

Ennis-Brown House Frank Lloyd Wright 1924

SOWDEN HOUSE

Mayan cave/temple transplanted into Los Feliz. Apart from the
Frey House in Palm Springs, this is as close as you'll get to
bouldering whilst buildering. If it had got too depressing for
Mr Wright always struggling to get out of his father's lengthy
shadow, he could always have given up the architecture game
and made a good living designing climbing walls or working
for Disney concert faking up mountainsides.

APPROACH

West Los Feliz.

101 CAVEMAN V4 18ft SD ★★

From the doorway out and up over the lower bulging rock face.

102 2000BC 5.10c 74ft ★

Start Caveman and then top out via the windowed corner to the
second rocky bit.

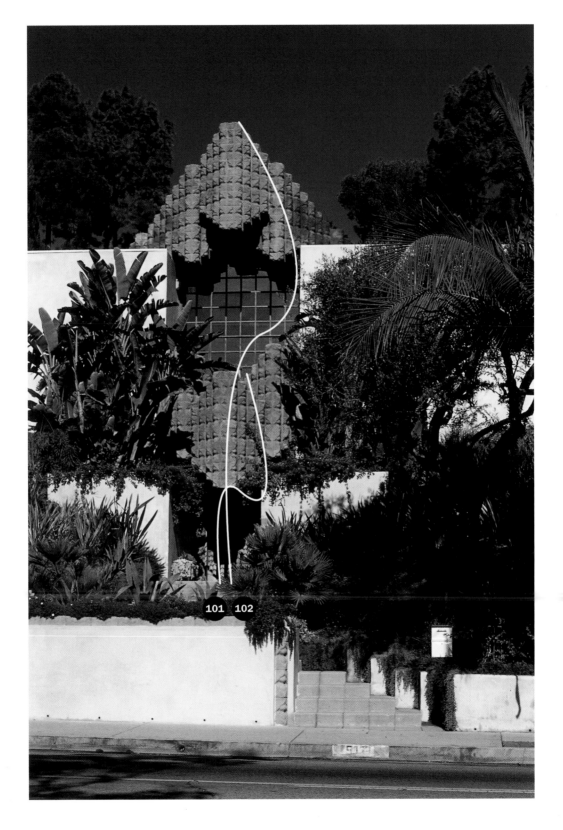

101 102

Sowden House Lloyd Wright 1926

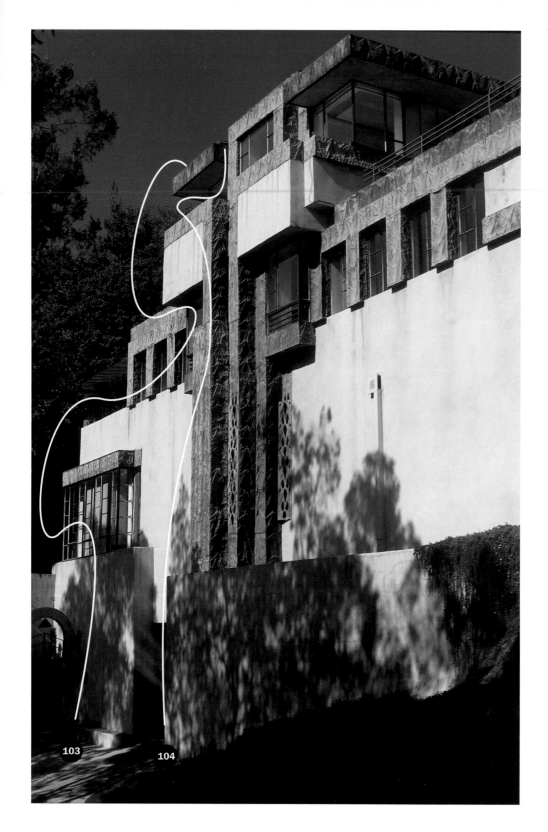

103 104

SAMUELS-NAVARRO HOUSE

Mayan fortress, built on an island with the steeply descending
road surrounding it. Pressed copper detailing takes over from
Frank's usual cast concrete blocks, and at the same time hints
towards Art Deco. A pool is contained on one of the higher
levels. Diane Keaton lived here.

APPROACH

Above Western Ave.

103 KAY CORLEONE 5.12a 135ft

From the ridge of the lower pedestrian gate delicately gain the
window ledge. Use the framing details to access the next level.
Lieback moves up again to the terrace and rooftop.

104 ALVY SINGER 5.8 65ft *

Chimney the green stuff above the garage.

SCIENTOLOGY CHURCH

"Thou art the man."
2 Samuel 12:7

If you get up this, then you are.

Big, blue and bizarre.

Patrolled by uniformed pistol packing John-Boy Waltons on bicycles. L Ron's place looks like nothing other than the Hotel California; twitching net curtains give no clue as to the activities within. Hundreds of rooms topped by the sinister never-to-be-finished block that must be the head of a kid's transformer toy, ready to rise up with the building and stride across the city smashing everything in its way.

If there were sneakers on every windowsill then it could, maybe, be a student hall of residence. Other than this it can only possibly be the headquarters of some strange religious cult. It's the massive size combined with the shoddy but cheery paint job that help make it so really, really scary.

APPROACH

Fountain Ave.

105 DIA-RRHOEA 5.13c 145ft *

Easy enough to the grand ledge over the door, but fairly desperate from then on. Stem out left in an all or nothing move and then bridge up past the five windows to the easier top section.

106 DIA-NETICS DIRECT 5.14 140ft **

Take the left-hand line of the three central window columns. Easier to get onto the first moves (than Dia-rrhoea), but you soon reach a small roof which if you're 7ft tall you may have the arm length to crank to the mantle. Otherwise, there is a small feature on this band, and this combined with a helpless lieback could possibly get you there. On passing the windows, as with US foreign policy, you'll either be joyously welcomed as a liberator or, more likely, told to push off back from whence you came.

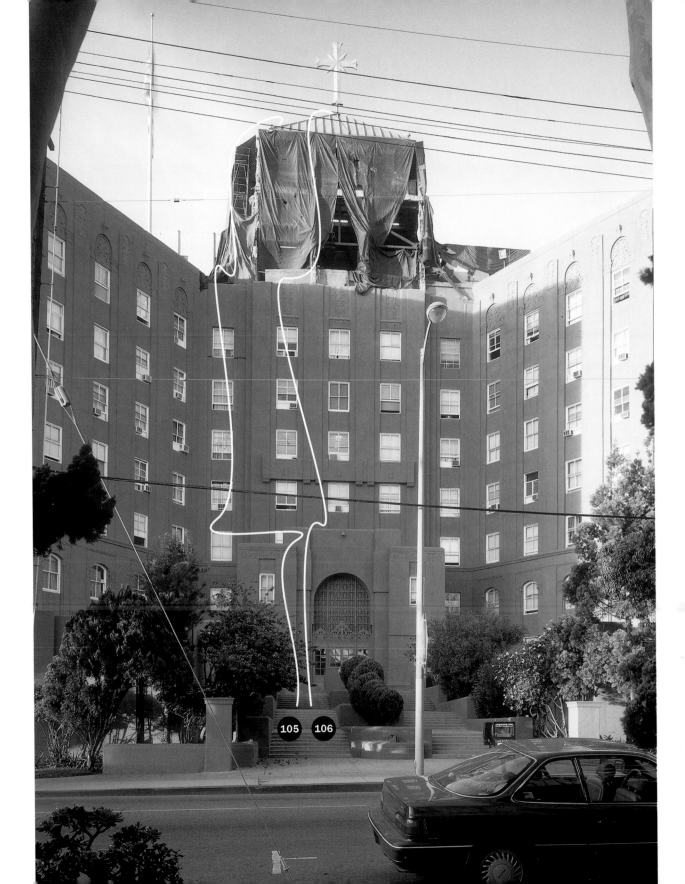

105 106

WILSHIRE

Long and straight – the apotheosis of the linear city. Named after (yet another) Marxist oil millionaire of the same name. This 16 mile boulevard slices through the lower city, and like a core sample, reveals much of how it lives and grows.

The commercial corridor bounded by residential neighbourhoods with the 'Miracle Mile' at its now weakening heart.

6150

AMBASSADOR HOTEL

BUCK HOUSE

200m

1000ft

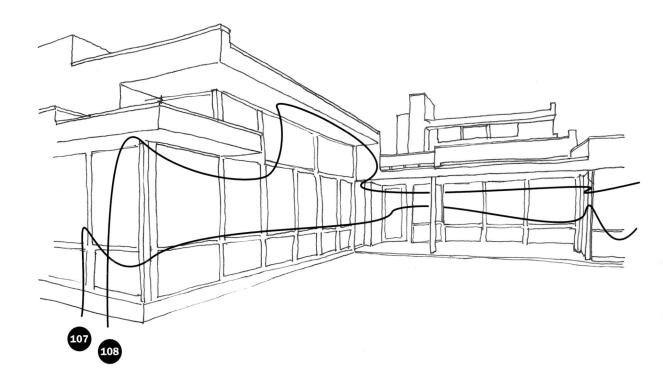

BUCK HOUSE

Huge Streamline Moderne frontage contrasts with large windows on private south facing garden area. Absolutely one of Schindler's finest houses, though in a kind of boring bit of town.

APPROACH

East of Fairfax.

107 GREENBACK V2 62ft **

Traverse the inner garden on the lower glazing bars.

108 YOUNG BUCK V5 86ft ***

Traverse the upper stucco volumes using fenestration details for feet.

Buck House R M Schindler 1934

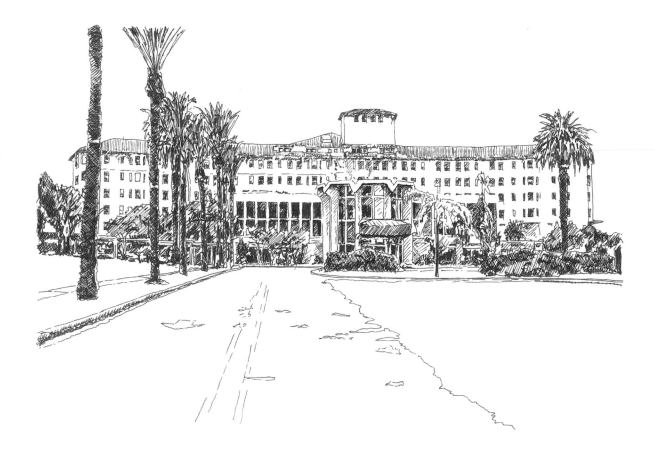

AMBASSADOR HOTEL/COCONUT GROVE

Bobby Kennedy got wacked here. Howard Hughes, Jean Harlow, John Barrymore and Gloria Swanson lived here. Every president from Hoover to Nixon stayed here. Joan Crawford, Carole Lombard and Loretta Young were discovered here, Bing Crosby started singing here and Marilyn signed to Blue Book here.

Donald Trump owned it and wanted to tear it down for development. It looks like it'll be demolished, but without the cash bonanza Donald envisioned, as the city has commandeered it for one of its new schools. For the meantime, it clings on behind the chain link fence, in limbo between party venue and movie location. Feels like Havana to me.

APPROACH

Up the palm lined driveway off Wilshire. Tell the limo not to wait.

109 DEAD KENNEDYS V5 16ft

Right of the entrance doors, bridge to the underside of the projected entrance canopy. Undercling the lower lip and reach for the vertical support.

110 FERRO ROCHE 5.9 64ft **

To the right of the entrance rotunda, where it meets the lobby's exterior, a chimney is formed. Get up it.

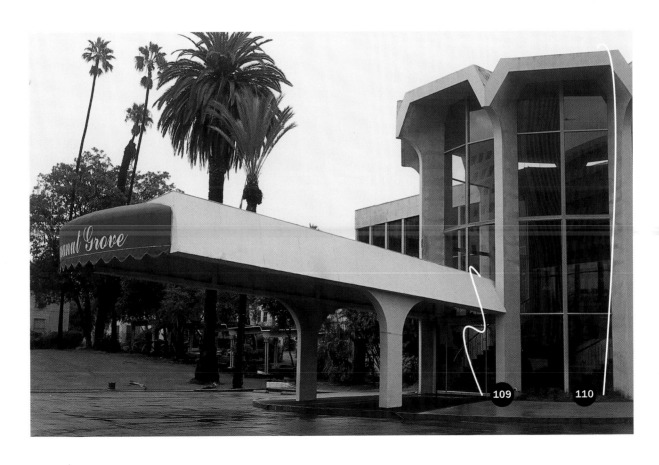

Ambassador Hotel/Coconut Grove Myron Hunt 1921

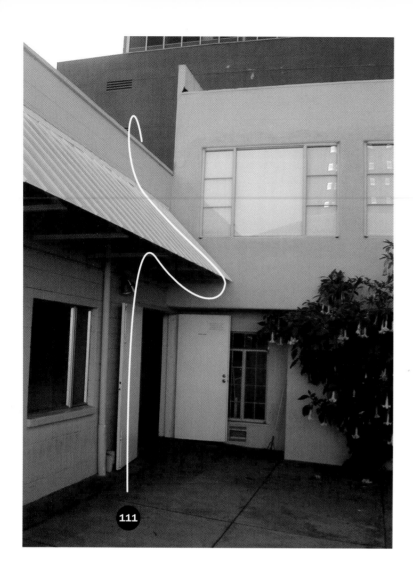

111

6150 WILSHIRE

Located at 6150 Wilshire is the most interesting grouping of galleries in the city, and Marc Foxx is probably the most consistently serious and rewarding amongst these. But any beauty to be found here lies inside the buildings rather than out. Nonetheless there are a couple of (almost) worthwhile routes.

APPROACH

6150 Wilshire.

111 FOXY LADY V4 27ft *

Drainpipe to corrugated canopy. Move to the corner, heel hook and rock over using the window ledge. If the gallery's open and you can use the door it goes at V1.

112 WHAT THE BUTLER SAW V3 47ft

When Foxx's doors are shut, bridge up the corner traverse left under the canopy and up at the east (open) end.

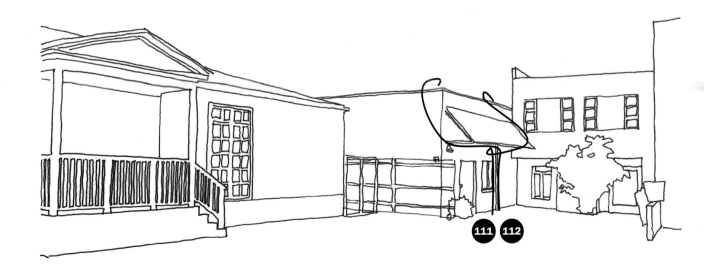

WESTSIDE/BRENTWOOD

A ridiculously big and arbitrary area defined as everything west of Hollywood but inland of the coastal 'communities'. Largely developed by Alphonzo Bell (of Bell Air) and the Western Pacific Development Co in the first decade of the last century.

Modelled on San Fran's plan of Golden Gate Park, it was always intended as residential lots for the upper class. In some way this explains why proportionally there are so few great houses here. This social class has always been too concerned with convention, and when they are adventurous it nearly always embraces ostentation.

GETTY CENTER

GOLDSTEIN HOUSE

STURGES HOUSE

200m

1000ft

SHEATS GOLDSTEIN HOUSE

Lautner's mountaintop eagle's eerie bond-villain aesthetic once again. Photographs can't really represent it – it has amazing views, but somehow can't be seen from anywhere, and once inside it's impossible to work out the structural feats that the house performs.

The Sheats built it on a budget, and other owners neglected it until silver trousered James Goldstein rescued it and let the architect go mad.

The house has a superbly louche sexy, casting couch type feeling. Could you say no as the floor-to-ceiling windows retract at the touch of a button, seeming to thrust the diamond shaped leather bed out into the shimmering night? As you give yourself up and lie back, the last thing you glimpse before closing your eyes is the flickering light filtered through the water of the swimming pool embedded into the ceiling above you. Resistance is futile baby.

APPROACH

Beverley Hills. Look for the jungle plantation.

113 **WARM LEATHERETTE** 5.9 135ft **

Highball it out over the pool.... Hand traverse up the sharp canopy edge. Right to left goes at 5.10 and the water's not there when you need it.

114 **ROHYPNOL** 5.11c 75ft *

Start contained in the lowest concrete waffle. Move up two, across one and back down. Tricky but nice landing.

115 **SEDUCTRESS** V6 35ft ***

Same basic moves as Rohypnol. Cross the back of the main room using the waffled ceiling. Fall out and you'll hurt yourself.

116 **ABANDON** V7 32ft

From the bedroom level below, use the tiny finger crack expansion joint to get poolside.

Sheats Goldstein House John Lautner 1963

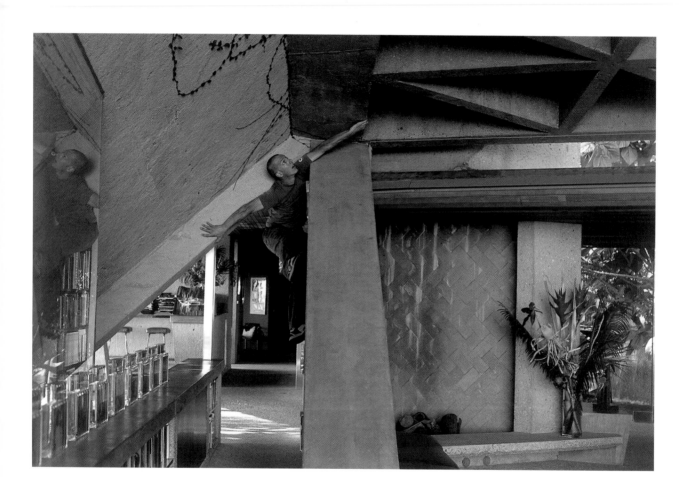

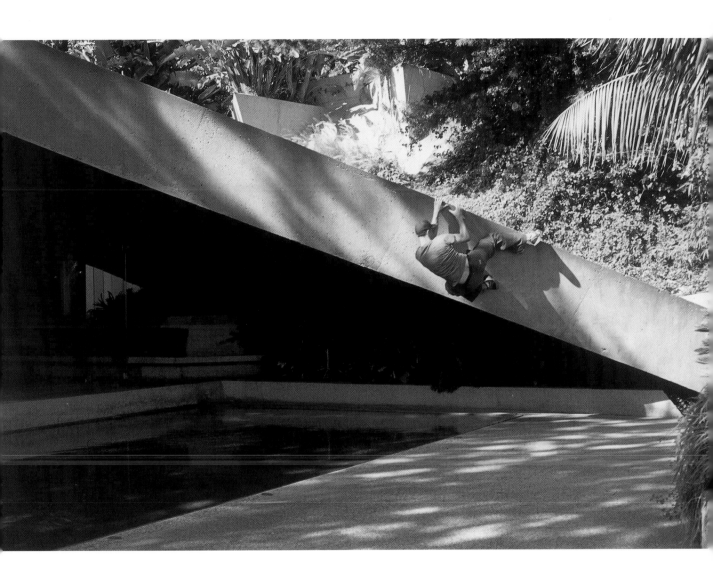

Sheats Goldstein House John Lautner 1963

STURGES HOUSE

"Do not despise the snake for having no horns, for who is to say it will not become a dragon."
David Caradine

Wright's only West Coast Usonian house, and what a beauty! Built of horizontally clapped redwood, the house is cantilevered high above a hilly precipice. Possibly slightly derivative of his pupil Schindler's How house, but you would never have got the master to admit that – and frank-ly who cares.

Tough finger splintering work to get out of from under the overhang with a crux move that bites you in the ass, and a second unexpected area of difficulty in passing through the sun shade.

APPROACH
Follow the speeding white Ford Bronco to Brentwood Heights.

117 SPLINTER V10 34ft *
Utilising the 45 degree overhang, move as far to the side of the house as possible. Ventilation holes in the brickwork make the move onto the vertical siding marginally easier. Once on the terrace, the overhung sun shade should be tackled more centrally.

Westside/Brentwood

THE GETTY CENTER

"Architecture is the art of how to waste space."
Philip Johnson

Although somewhat of an architectural disaster, 1980s museummeister Meier's arrogant hilltop castle utilised 16,000 tons of rough-hewn travertine marble, which covers a surface area of over a million square feet. This provides an infinite choice of climbs, indoor and out, low or exposed, but all of easy grade due to the splitting system used on the marble blocks and the installation process that results in clear ledges on much of the cladding.

There are almost as many employees as visitors here, with guards posted at every corner and Prada wearing curators strolling aimlessly around. But as with the general ethos of the center, there is an unregulated – walk on the grass if you want to – freedom to the place. Unlike anywhere else in Los Angeles really. No one tries to tell you anything, and if you must buy something you pay only the fair price for it. Weird, I know. If kids run through the flowers or bushes no one seems to mind and mysteriously they're replaced before the next day. You get a strong kind of *The Truman Show*/*Groundhog Day*/*Westworld* feeling. Most employees appear to just ignore climbers.

Fantastic self-curated temporary exhibitions and mouth-wateringly bad eighteenth century French gaudy gold stuff. Superb library.

The worst architectural feature, the unresolved problem of how to deal with the smooth edge thickness of the marbleblocks in the external corners, provides the most interesting feature for the climbs. The clad columns around the Garden Terrace Cafe and off the main courtyard provide dramatic direct lines with much exposure, although these are also the most populated areas.

Don't be too alarmed by the creaking of the cladding when weight loaded, the anti-earthquake system used allows for the marble blocks to move – although it does take some getting used to.

Note: Allegedly someone recently threw themselves off some high bit, hoping to make it look like an accident and thus enable their family to sue.... Subsequently they, sadly, seem to be taking a little more interest in climbers.

APPROACH

Getty Center Drive.

118 OILY 5.7 110ft **

Because of the evenness of installation (half-inch horizontal spacings), and the unevenness of the natural marble, all routes utilising the stone go at this grade. It's a positive playground with infinite options, only restricted by your desired level of exposure.

Getty Center Richard Meier 1994

EAGLE ROCK/GLENDALE/PASADENA

"I am of the snake that giveth Knowledge and Delight, and stir the hearts of men with drunkenness. To worship me take wine and strange drugs.... They shall not harm ye at all. It is a lie, this folly against self.... Be strong, Oh man! Lust, enjoy all things of sense and rapture... the kings of the earth shall be kings forever; the slaves shall serve."
Aleister Crowley

Lifelong climber and the devils own representative on earth, Aleister – the great beast – Crowley, set up the Ordo Templi Orientis in Pasadena in the 1930s. John Parsons a young Los Angeles aristo and pioneer of Cal Tech rocketry took over and therein performed blasphemous rituals of sexual necromancy. He in turn brought in his friend L Ron Hubbard who went on to use later what he'd learnt there. Parsons blew himself and his mansion up with his famous rocket fuel after Ron had stolen his mistress and he'd failed in his attempt to create the "whore of Babylon".

Incidentally, at the turn of the century Crowley led an expedition to Mt Kanchenjunga, the world's third highest peak. The attempt ended after Crowley callously and unrepentantly caused the death of all porters and several of his party. Glendale and Eagle rock are nice too.

RODRIGUEZ HOUSE ■

■ ART CENTER

■ KUBLY

PLAYGROUND CLUBHOUSE ■

200m

1000ft

RODRIGUEZ HOUSE

At first it seems craftsman meets de Stijl, but the house really does perform some fantastic structural layerings, both in materials and directions, as it progresses back into the garden space. Immaculately looked after, with the horizontal bands of differing materials requiring an enjoyable dyno to reach the balcony ledge.

APPROACH

Exit Glendale Fwy at Mountain St.

119 WOODY V0 16ft SD

Start seated amongst the bushes at the southeast corner. Climb the crimpers to the ledge and mantle to the top.

120 DESPERADO V3 45ft SD ★★★

Start as with Woody, but traverse the tight brickwork to the doorway. Climb out of the overhang and crank for the balcony siding. Move up the timber framing to the roof.

121 EL MARIACHI V2 40ft SD ★

Traverse the lower brickwork only from east to west. No wood, so bridge at the doorway. Crux move around tree after door.

122 EXTRA WOOD V3 38ft SD

Climb Woody to the ledge then traverse under the eaves to the north. Mantle to the roof at the final cross-member.

123 CRAFTY V4 28ft ★

On the east face of the house through the gate, the first floor gracefully passes over a void to the garden. Climb the right hand wall to the underside of this roof 9ft above the stone floor. Without using the side wall climb out to the garden side.

Again climb Woody to the ledge. Move right on the narrow band of stonework only. At the right hand wall move under to finish Crafty.

124 REALLY WOODY 5.11a 220ft ★★

From the front door traverse the entire circumference of the house firstly under the balcony and then under the eaves. Use only wood for hand and feet.

125 STONY 5.9c 220ft ★

As for Really Woody, but traverse using stone only.

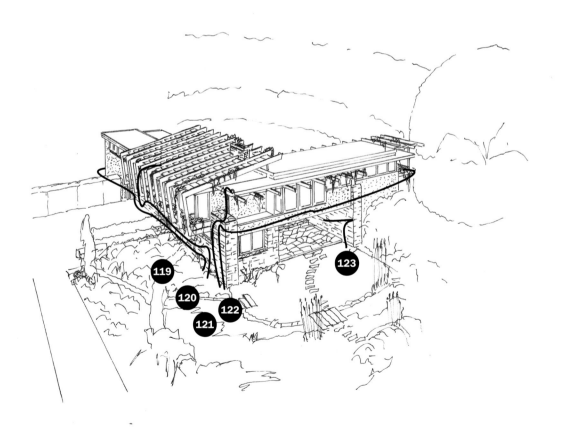

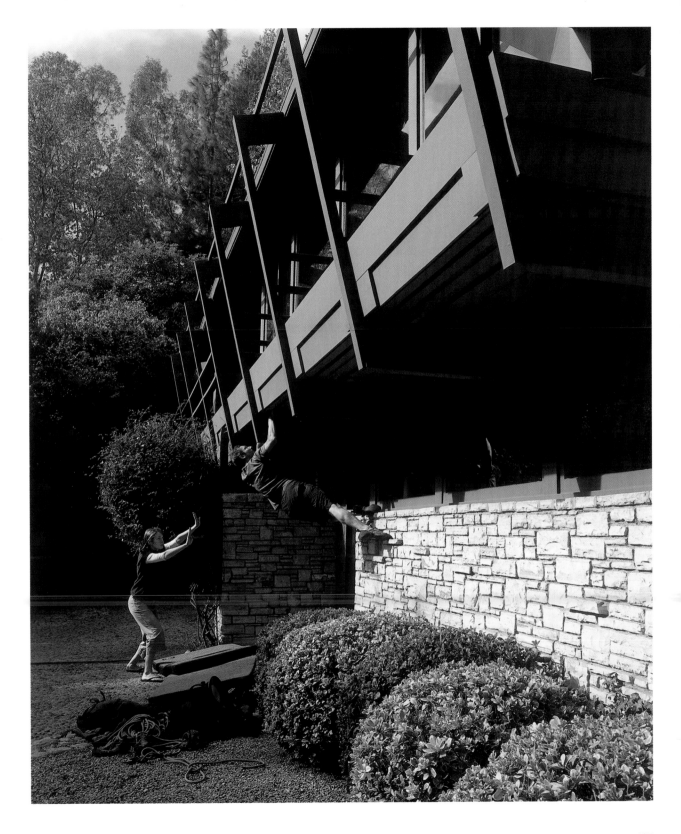

Rodriguez House R M Schindler 1941

Eagle Rock/Glendale Pasadena

EAGLE ROCK
PLAYGROUND CLUBHOUSE

Isolated and a bit run down, barely recognisable from the coffee table architectural books you will have seen it in. Shulman's beautiful photographs look like they were taken on the day of completion, since when it's been a sad and steady decline for the clubhouse.

APPROACH

1100 Eagle Vista Drive.

126 I-BEAM V4 34ft **✱✱**

Unite the various volumes via the southeastern corner post.

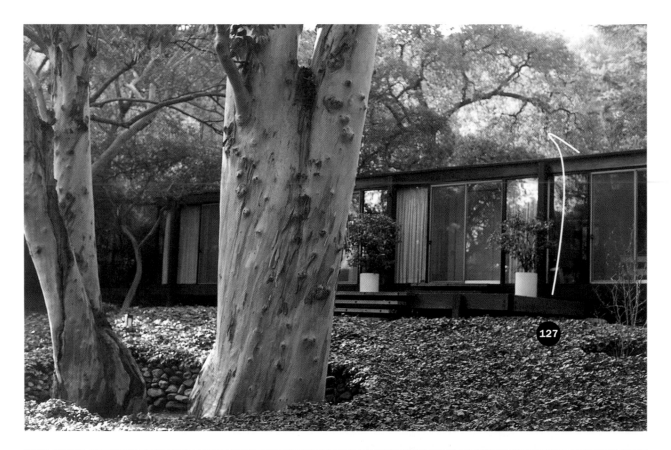

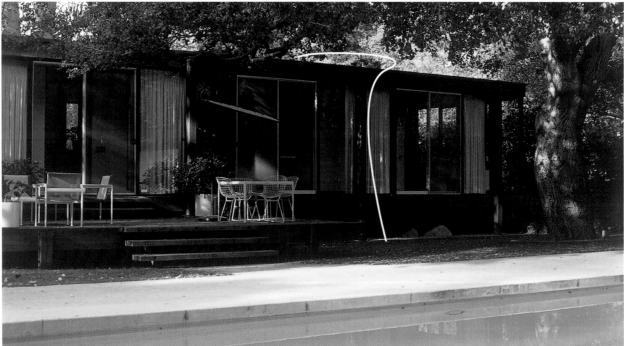

KUBLY HOUSE

Wooden Miesian precursor of Art Center, which as dean, Kubly also commissioned.

APPROACH

West of the Rosebowl.

127 **OFF CENTER** V1 42ft SD *

From one platform at the front – to its mirrored reflection at the rear. Use vertical support post and bridge using the glazed unit. Walk across and down the garden face to poolside platform.

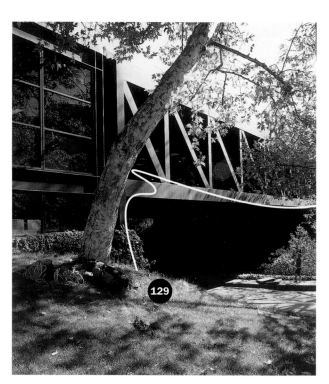

ART CENTER COLLEGE OF DESIGN

Similar to the feeling you get with Lautner houses, there's a Masters of the Universe association with this architecture and its setting. The building as bridge, and as factory of ideas. One bridles with jealousy at the privilege of the students, and the venue conveys a sort of swaggering arrogance on those studying within.

Ellwood had nothing to do with the annoying plant and extractors, etc., on the roof.

APPROACH

1700 Lida Street.

128 TOMORROW BELONGS TO ME 5.10b 325ft **

Massive traverse along the entire northern face. At once balancy along the window sections and pumpy through the overhung bridge part.

129 FATHERLAND V3 96ft

Move along the windows of the library using the roof beams on the outside walkway.

130 GOD GIVEN RIGHT V2 44ft SD **

On the stairs to the main entrance, from seated work your way up the treads to the steel platform. All railings are off. Once you meet the building, pull upright to the framework and move up to the roof.

MALIBU

Rich people live here, and generally speaking they don't want you anywhere near their houses.

Razorwire topped gates defend the clifftop communities. Parking restrictions prevent you from leaving your car. Guards patrol the 'private' beaches in an effort to intimidate, and the houses turn their backs and link hands to seal any chink in their defence against access to the shoreline. This they call 'community' – i.e. this community has united, bonded and worked tirelessly together in order to keep you away. Obviously there's something here they want to protect, and there are spectacular homes of every style, including ostentation on a similar scale probably only found in Florida. Enjoyable sport and house watching can be had in long scrambles below the cliffs, getting you comfortably up the noses of the beach 'owners'. However, beware the last laugh isn't theirs as the 26 mile coastline seems to have only about 200 feet of public access and finding and getting back to it can be tough outside of low tide.

WEIRD HOUSE

LIFEGUARD TOWER

EAMES HOUSE AND STUDIO

LOVELL BEACH HOUSE

200m

1000ft

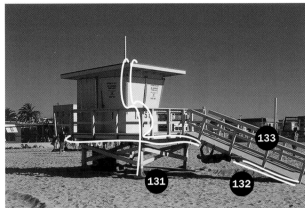

LIFEGUARD TOWER

Managed by the Fire Department, there are several varieties, with the latest design currently being phased in. Graveyards of the old ones, and storage depots for the new pop up at points along the coast. For most locals these are their first and only buildering projects – when as kids they attempt the lower traverse.

APPROACH

PCH.

131 **PAMELA** V3 65ft SD ★★

Using only the platform and the ramp, pass all the way round. Finish back on the sand.

132 **TOMMY LEE** V2 18ft SD

From one of the front corner posts pull up to undercling the platform. Up onto the rail and haul ass up to the roof. V4 if you don't use the rail and the storm shutters are up.

133 **HONEYMOON VIDEO** V4 45ft SD ★★

Half Pam and half Tommy. Pam it to the platform and pull up onto it. From standing use the shutters to get to the roof.

WEIRD HOUSE

Kids toy house frontage scaled up, beamed down and perched on an ocean view site.

APPROACH

Point Dume.

134 POINT(LESS) – DIRECT 5.9 21ft

Straight up just left of the front door. Windowsill to fly-away horizontal detail. Left to upper window and conquer the lip.

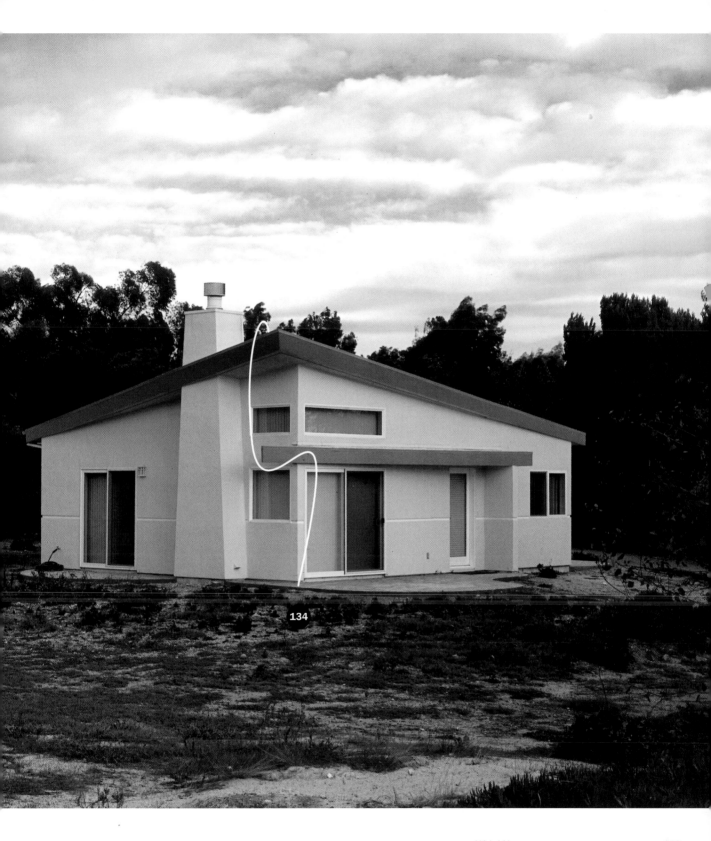

134

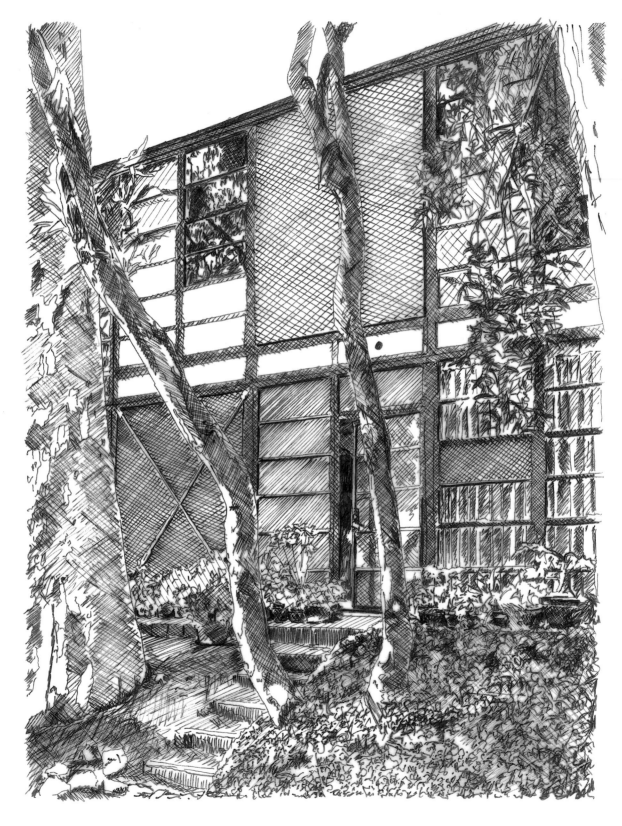

EAMES HOUSE AND STUDIO

On a fantastic site in the Palisades, overlooking the ocean and set amongst eucalypti, the metal framed box that the designer couple built has come to be known as one of the greatest houses of the twentieth century.

Both humanistic and individual within the framework of hard-edged modernism, and reflecting strong Japanese influence, the ideas of Schindler can be clearly seen in the way the house relates to its setting.

APPROACH

Pacific Palisades.

135 RECLINER V5 125ft *

Traverse three faces of the house, moving up and down as necessary.

136 OTTOMAN 5.7 36ft **

On the southwest corner, climb the south horizontal glazing, switch westwards and easy up to the overhung roof. Swing out and up over the lip.

137 FLIP BOOK V5 21ft SD *

To the left of the door is a double window unit replaced with blank black board and stainless cross tensioners. Pull onto these and walk up. Reach beyond the pale blanks to crimp holds to the roof.

138 LEG SPLINT V4 21ft **

The Mondrian colour solids fit flush into the frames so offer little purchase. Crimp up left of the living room door up to the roof.

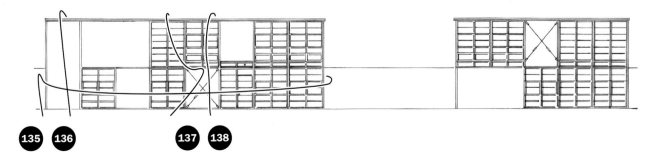

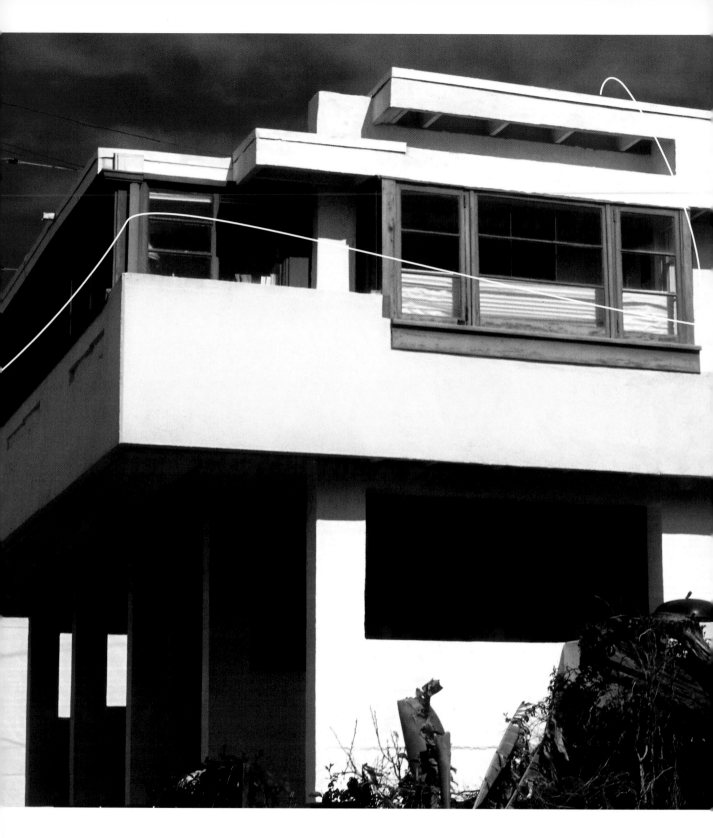

LOVELL BEACH HOUSE

"Now I was consumed with the irrepressible desire of looking below... for one moment my fingers clutched convulsively upon their hold, while, with the movement, the faintest possible idea of ultimate escape wandered, like a shadow, through my mind – in the next my whole soul was pervaded with a longing to fall...."
Edgar Allen Poe

Our hero Rudolph's masterwork was built as a weekend retreat for the same fitness guru as Neutra's classic Lovell Health House. The beach house is less crisply modern, but beautifully inventive with a complex mix of single and double height spaces. A really powerful building, although I'm not sure how many weekend breaks I need to take in today's Newport Beach.

APPROACH
Newport Beach.

139 SLIP SLAP SLOP 5.7 46ft *
From behind the tree in the garden, go left above the large doors and conquer the roof volume via the un-recessed smaller window.

140 DON'T GET BURNED 5.10a 245ft
Take Slip Slap to just below the roofline. Traverse the entire glazed upper section left, all the way to the rear of the house and descend the drainpipe. The rooflip itself is off.

139 140

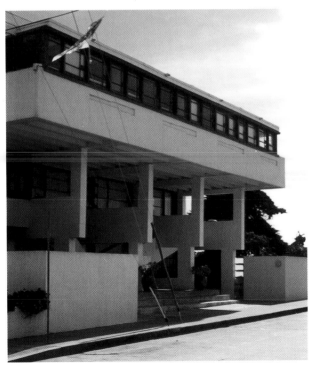

LAX/WATTS

Not an area at all, but Watts is en route to the airport for most people, and the sign isn't en route to anywhere.

LAX underwent massive restructuring before the 1984 Olympics, and much of the scale of the original plan has been lost. Still, for a major urban air hub it still works better than any other. Outside of rush hour it's super-speedy to get to.

Watts on the other hand didn't undergo massive restructuring, and there probably never was much of a plan for it to lose.

LEVITZ SIGN ■

WATTS TOWERS ■

■ SKYLON

200m

1000ft

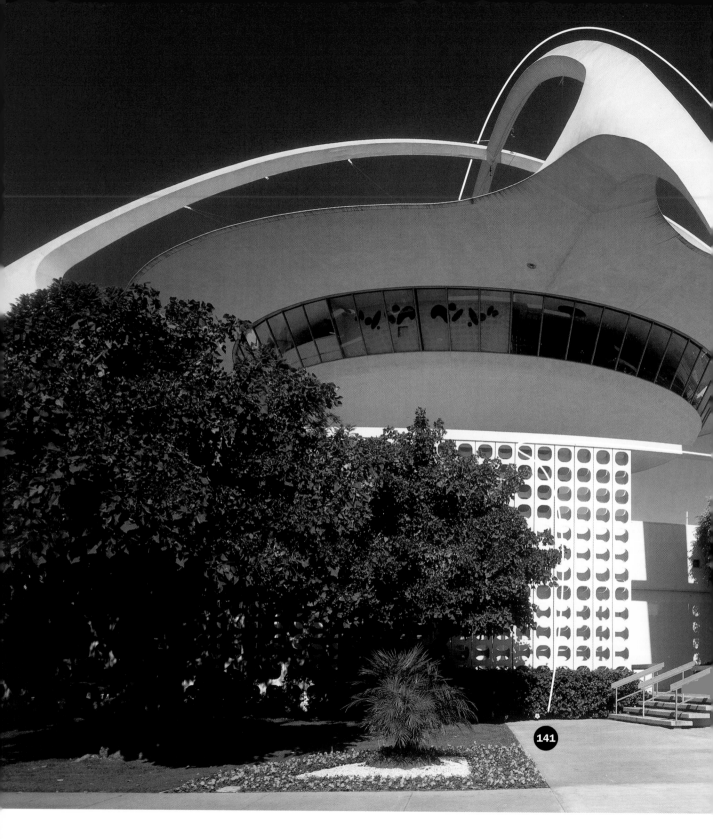

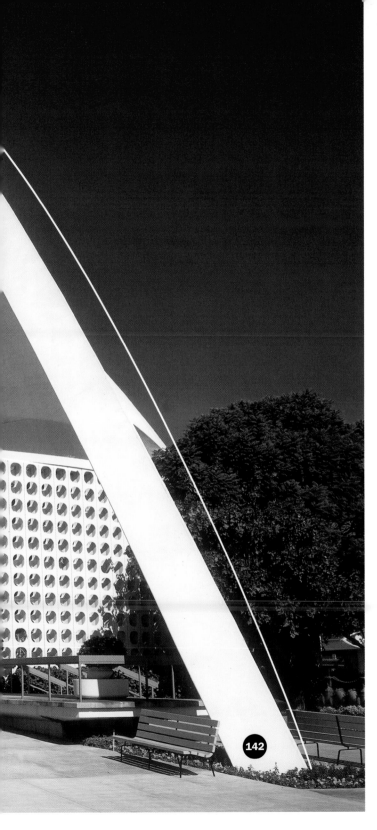

SKYLON (LAX THEME BUILDING)

"... they put Ming the Merciless in charge of designing California. Favoring the architecture of his native Mongo, he cruised up and down the coast erecting raygun emplacements in white stucco. Lots of them featured superfluous central towers ringed with those strange radiator flanges that were a signature motif of the style, and made them look as though they might generate potent bursts of raw technological enthusiasm, if you could only find the switch to turn them on."

William Gibson

Death as a suspected terrorist – deportation as a foreigner – or at the very least, a night on the inside. These are the only likely outcomes of attempting this highball traverse.

It's a great building, designed in times of segregation, by the first black fellow of American Institute of Architects. Although now a little swamped and hidden by the expanded airport, it offers us the untarnished pure dreams of the space age. The framing of the sky through the legs of the building still makes this Jetson's spacecraft hover, and it is the centrifugal hub around which all the speeding transportation systems revolve.

APPROACH

LAX.

141 **ROTUNDA** 5.8 225ft
 Circumnavigate the perforated sun screen walls. High hand traverses over the entrances.

142 **DEPORTATION GUARANTEED** 5.10c 145ft *****
 Bizarre sideways – shuffle, awkward repeated lieback on sloper moves are required, and the decent is hairier still; barely controlled sliding (into the waiting arms of the law).

'NUESTRO PUEBLO' –
SIMON RODIA'S TOWERS IN WATTS
A.K.A. WATTS TOWERS

"I had it in my mind to do something big and I did."
Simon Rodia

In a city of segregation, where people keep so strictly to only what they know, midget Italian obsessive outsider Simon Rodia, (a.k.a. Simon Rodilla, Sam Rodia, Don Simon and Sabatino Rodia), provides the sole reason why any of them come to visit this part of town.

Obviously the inspiration for the mashpotato tower scene from *Close Encounters*, Paris' Eiffel Tower and Barcelona's Sagrada Familia Cathedral.

APPROACH
Watts.

143 100 WATTS 5.6 95ft **
All the towers go at, or below this grade – fun though.

144 60 WATTS V1 205ft
Traverse the outside mosaics.

Watts Towers Simon Rodia 1921-1945

145

LEVITZ FURNITURE SIGN

"The Pharisees and Sadducees came to him and tested him by asking him to show them a sign...."
Matthew 16:1

Peachy big sign, now cast adrift in a McDonalds car park.

There's no reason to stop here other than this sign – especially as the new road to Josh now bi-passes this cultural dust bowl. Bill and Ted came from here.

Nothing to protect, rotten vertical wooden slats, airy and very scary.

APPROACH

Somewhere off the 605 between the 210 and the 10.

145 THE SIGN OF THY COMING 5.13b 194ft

Because it's falling to pieces, you could get something in behind the occasional wooden slat. No fun at all until you reach the triangle. From here move into the center and up the pole. Lieback the edge of the ellipse and use the L of Levitz to summit. Come down via the internal structure.

PALM SPRINGS

"Escape for thy life; look not behind thee, neither stay thou in all the plain; escape to the mountain, lest thou be consumed." Genesis 19:17

Head out to the Coachella Valley on Interstate 10. Start looking around once you get to the dinosaurs and the windmill farms. Palm Springs is that green bit below the mountain off to the right. To avoid all the unnecessary madness, bare left and go direct to Joshua Tree.

DINOSAURS

VALLEY TRAM STATION

TRAMWAY GAS STATION

MILLER HOUSE

KAUFMAN HOUSE

FREY HOUSE II

200m

1000ft

TRAMWAY GAS STATION

The soaring landmark canopy greets you as you enter the city from the east. Sterilised now by the containing wall, and living a tamed life somewhere between a disused art gallery and the new Palm Springs visitor center. But you can still see the power of the form and the skill of the engineering.

APPROACH

On the way in.

146 HYPERBOLIC PARABOLOID 5.11a 32ft

Up the highest support post and mantle to the apex.

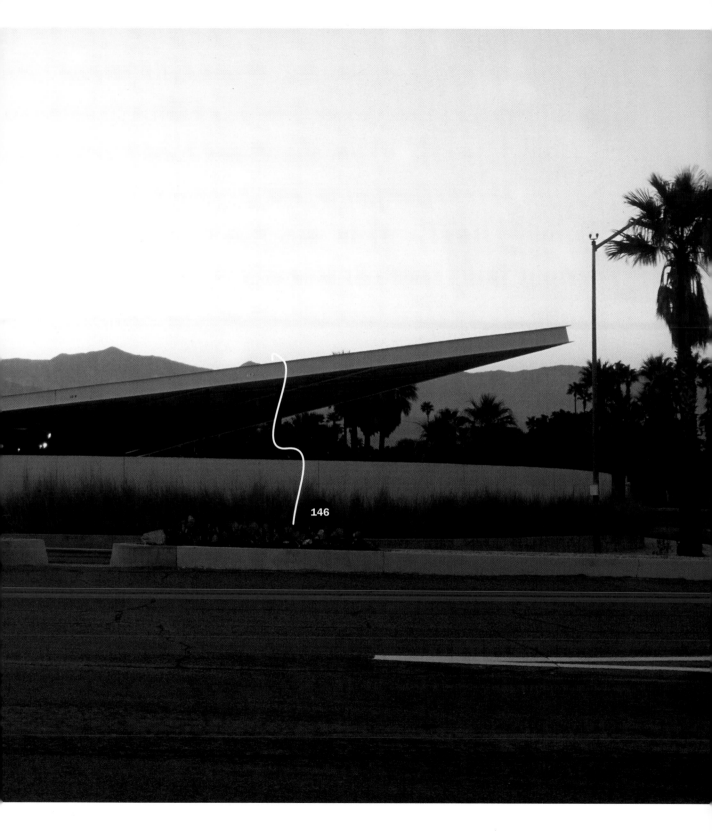

146

Tramway Gas Station Albert Frey 1965

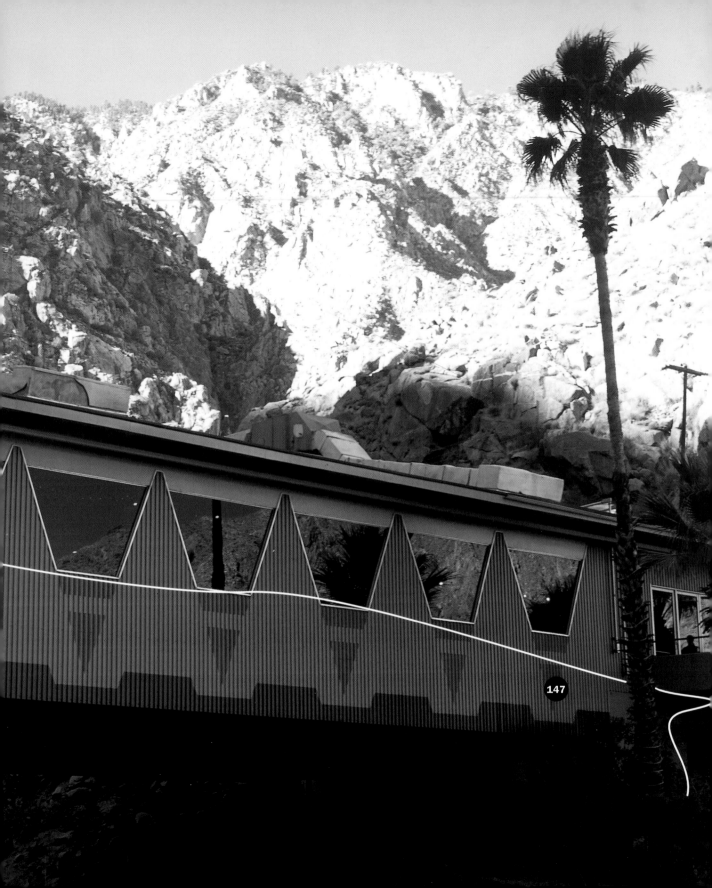

147

ARIEL TRAMWAY VALLEY STATION

Anything that provides a way out of this town gets my vote as a good thing worth preserving. Indeed, the station may need some support as the current owners look to make the experience of the tram a little more white knuckle and increase their merchandising opportunities Disney concert-style.

APPROACH

Westward up the mountain from the gas station.

147 PONTOON 5.10c 64ft

 Traverse the windows from the entrance.

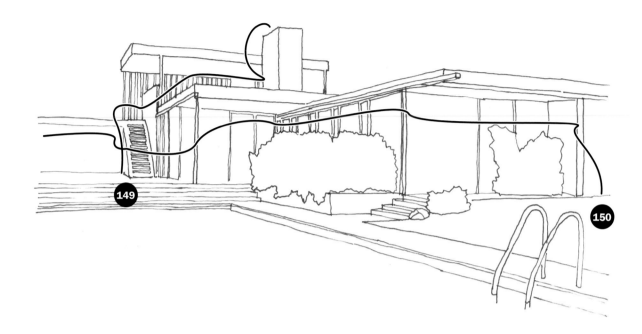

KAUFMAN HOUSE

Could it really be just luck that you happen to commission two of the seminal buildings of the twentieth century? Edgar Kaufman did. A decade after building Fallingwater he made this winter retreat with Neutra. An absolute classic, though it went through some hard times (Barry big-nose Manilow owned it) and it's now been renovated/restored/rebuilt depending on how you wish to look at it.

After your grandfather's death your dad replaces the handle of the dead man's beloved axe. Years later, after much service it is passed down to you as the treasured heirloom and symbol of the passage to manhood that it has become. You in turn replace its now worn-out head. Is this axe still the axe of your grandfather?

It goes something like that. Point being, that a brand new building stands where the old one was and the new building looks almost exactly like the old one. (This look is a good look.)

Shame about the new pool house.

Anyway, past the boulders in the driveway, a tightly layered stone wall greets you. This runs at various points through the whole house and into the immaculate garden. Staying on this looks really easy, but it's very crimpy and balancy and provides no rest spots. Very hard to sustain in the heat.

APPROACH

West of Indian Canyon Drive.

148 REPLICANT TRAVERSE V5 65ft *

Starting at the glass front door, crimp all the way over the gate and round to where the wall ends at the garage.

149 MARMOLED V4 84ft SD **

Start behind the garden stair. Move up the underside and come out right onto the rooftop gloriette. Crimp the face of the chimney until you can lunge for the top.

150 LIKE DÉJÀ VU, ALL OVER AGAIN V3 143ft **

Traverse the easier low garden wall towards the house. Move left below the projecting roof plane. Continue round taking in each of the expanding volumes.

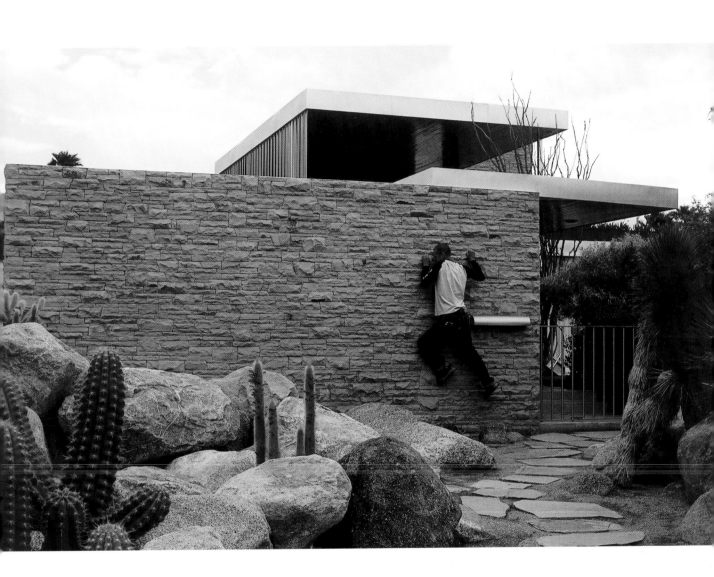

Kaufman House Richard J Neutra 1947

MILLER HOUSE

This beauty now looks like it's the sole survivor of some sort of modernist cleansing. Where once it sat unfenced in the open desert as Grace Miller's isolated retreat for the practice of the Mensendieck exercise program. It's now hemmed into seedy suburban Palm Springs.

APPROACH

South of Racquet Club Rd.

151 ALONE V2 12ft SD *

From seated beside the shallow water pool, pinch the lowest window section. Rock up using the verticals and reach the roof adjacent to the chimney.

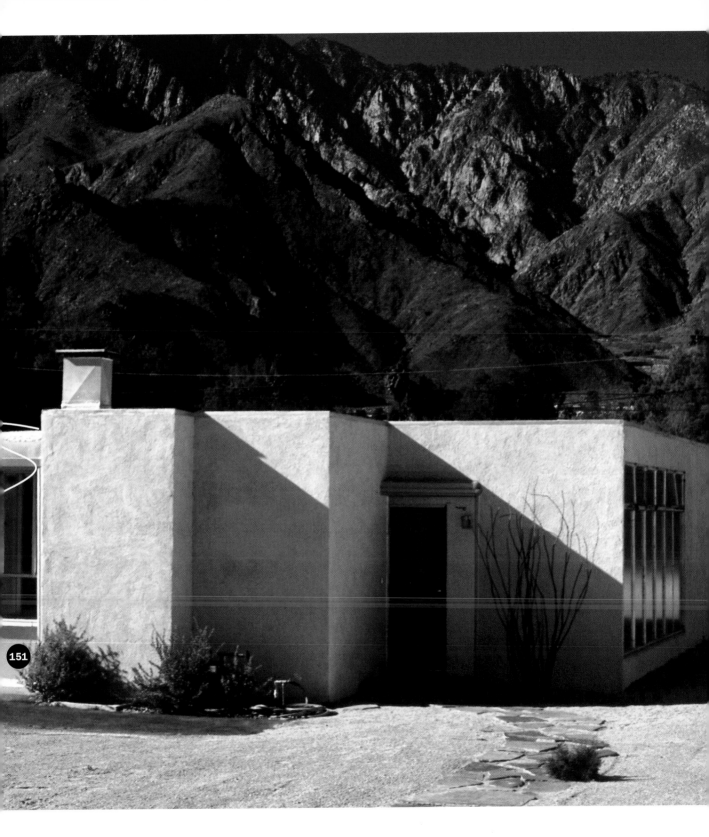

151

Miller House Richard J Neutra 1937

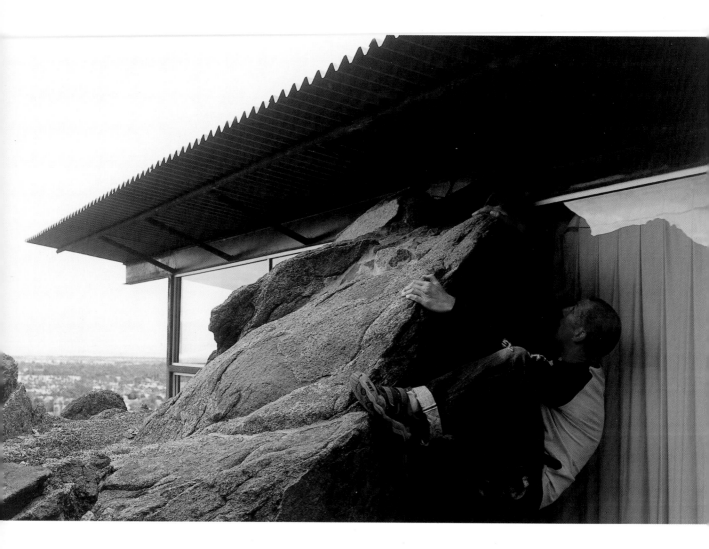

FREY HOUSE II

Up a private road on the mountain overlooking the strangeness that is Palm Springs, and with an integrated boulder projecting through the rear glazed wall. There's a whiff of desert white skank about the corrugated roofed shack, but the interior is beautifully fitted out in the spare trailer style familiar to desert communities and *Wallpaper***/Dwell* readers alike.

The house fits its situation simply and superbly. It occupies the best site in Palm Springs and does it without ostentation. A rare thing indeed.

APPROACH

Above the museum.

152 FEY V4 24ft SD ★★

From the lowest asphalt level next to the carport, climb the lighting details. Crimp the thin mortar line and inset light fixture. Mantle up and traverse right to the pool.

153 BAMBAM V6 63ft ★★

From the northwest corner traverse round the back of the house, over the integral boulder and round to the pool.

152

Frey House II Albert Frey 1963

154

DINOSAUR

"Climbing would be a great, truly wonderful thing if it weren't for all that damn climbing."
John Ohrenschall

Don't spend too long thinking about it, just ignore the form and consider the beasts as surface only – it's easier that way. No dynos.

APPROACH

Hard to miss really, 10 East.

154 TYRANNOSAURUS 5.10a 75ft *****

From the rear of the right 'leg', move up to the back of the knee. Hard face moves to gain the plastic Jurassic creature's back. At the neck it steepens again and the crux moves take you from the neck folds to the sloping jaw line. The eye can be gained from there.

155 APATOSAURUS 5.7 124ft

Just get to the head. There's a shop inside this one.

Notes

Notes

LA Climbs
Alternative Uses For Architecture

Copyright 2003
Black Dog Publishing Limited

Design by Gavin Ambrose

Architecture Art
Design Fashion History
Photography Theory
and Things

Black Dog Publishing Limited

Studio 4.4
Tea Building
Shoreditch High Street and
Bethnal Green Road
London E1 6JJ UK

T 44 020 7613 1922
F 44 020 7613 1944
E info@bdp.demon.co.uk
www.bdpworld.com

Black Dog Publishing
PO Box 20035
Greeley Square Station
New York NY 10001-0001 USA

T 00 1 212 684 2140
F 00 1 212 684 3583
E pressny@bdpworld.com

Thanks to

Tania and Frank
Mark the shark
Shirley Morales
Soo Kim
Michael Worthington
Phil and Heather
Mum
Kelly Taylor
Linda Burnham
Frank Esher and Ravi GruneWardena
Russ Leland
Darin Johnstone
Heather and John Banfield
James Goldstein
Charlotta Stahl
Cara Mullio
LouAnne
Meg
Chad
All at BDP
All at Victoria Miro Gallery

Alex Hartley is represented by
Victoria Miro Gallery, London
and Distrito Cu4tro, Madrid.

CLIMBS